l. moholy-nagy

Arts Council of Great Britain 1980

This catalogue accompanies the exhibition of Moholy-Nagy's works
arranged by the Arts Council of Great Britain, shown at the
Institute of Contemporary Arts, London, 12 January–10 February;
Leicester Museum and Art Gallery, 16 February–16 March;
Scottish National Gallery of Modern Art, 22 March–20 April;
Hatton Gallery, University of Newcastle-upon-Tyne, 26 April–17 May, 1980

Exhibition and catalogue designed by Peter Rea
Archetype Visual Studies London
Design assistant Christopher Stanbury

Catalogue filmset by Diagraphic Ltd in VIP Helvetica
body text 8/9½pt regular, medium, bold; track 1 spacing; justified;
titles in Helvetica Bold 18pt

Printed in England by CTD Printers Ltd

ISBN 0 7287 0224 X

Contents

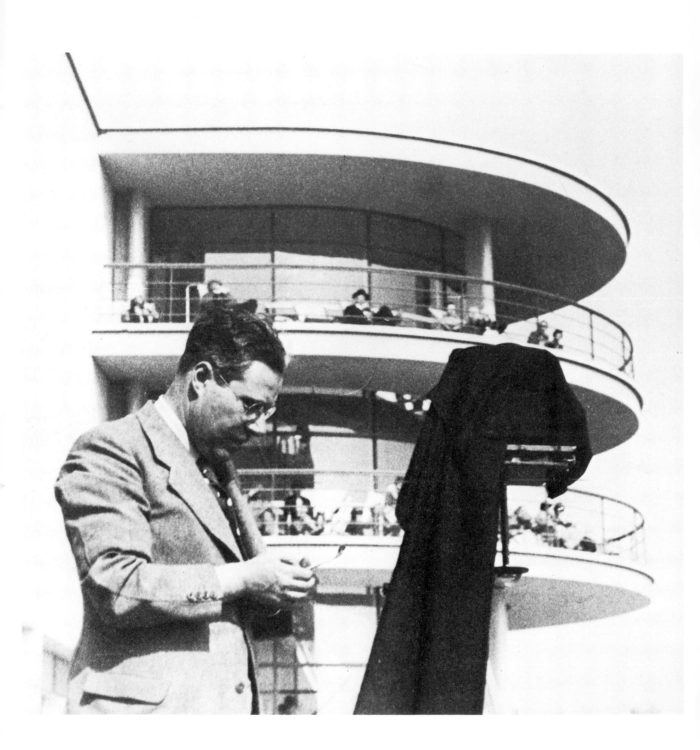

László Moholy-Nagy at Bexhill, England
photographer unknown

Moholy-Nagy
Foreword

These months in London have something of the air of an Hungarian festival; Kertész at the Serpentine, the Eight and the Activists at the Hayward and Moholy-Nagy at the ICA. And all these exhibitions are also being shown outside London.

Moholy features in two of these exhibitions and had a profound influence on Kertész's chosen medium, photography. He typifies that twentieth-century artist, who was able to turn his hand to all media, jack-of-all-trades and master of all. He saw that all forms of creative expression were equally valid, and was a painter, photographer and designer.

Arguably his greatest contribution, his work as an educator at the Bauhaus in the twenties and at his own Institute of Design in Chicago in the forties, is difficult to exhibit and does not appear here. Suffice it to say that his teaching methods are still fundamental to all art schools now.

We are grateful to all the lenders to this exhibition, especially to Moholy's friends when he was in England between 1935 and 1937 and most of all to his daughter Hattula who has lent not only paintings but rare photos from her archive.

Joanna Drew Director of Art,
Richard Francis Exhibition Officer

László Moholy-Nagy activist painter 1917-1921

by Krisztina Passuth

MA was published by
Kassák in exile in
Vienna after 1919.

Hungarian avant-garde painting and literature emerged in Budapest in the years of the First World War during which László Moholy-Nagy started his artistic career. The branch of the movement known as Activism was launched by the writer-painter Lajos Kassák. After the banning of the short-lived journal *Tett* (Action) 1915, Activism developed within the journal *MA* (Today) 1916—1925. Although Moholy-Nagy's name did not appear in the journal while it was published in Hungary, it is clear that MA shaped not only the artist's painting style but his view of the world and his whole later conduct as a human being. The works produced from 1917—1921, primarily the drawings, indicate his commitment to Activism. But there are just as many of the ideas which appear in his earlier and later writings. Moholy-Nagy became an important creator, not in Hungary, but after 1920 when he had left, and a pre-condition of his real development was his progress beyond his earlier style. It was, however, this previous commitment which made it possible for him to maintain his own roots and his own autonomous world throughout his many changes of style and environment.

Activism was in all respects a synthetic trend which, at the same time, shut out eclecticism. It embraced the latest aspirations in literature and the fine arts. Twentieth century Hungarian prose and verse created their own bold variations. Numerous trends, from Futurism to Expressionism, from Czech Cubism to that of the Russian, Chagall, were introduced into the fine arts. The discovery of new Hungarian talent was on a similarly broad scale; what was good and new, from the compartmentalised Cubist style to freely moving colour composition and robustly realist modes of expression, could find space in the journal. Finally, however, Activism showed the way ahead, far beyond 'art for art's sake'. If not all individual artists without exception were personally involved, the whole movement worked together in preparing the revolution and in sketching the outlines of a better social order.

After the outbreak of the World War, the birth of Activism came in most difficult times, within the confines of the Austro-Hungarian Monarchy, when the traditional ways of life had not yet been blown apart by changed socio-economic conditions and when academic norms were still valid in painting. The majority of the intellectuals still did not realise what war meant and that a new social order was being born before their eyes.

Activism began at the same time as Zürich's Dadaism, without having anything to do with it. The Hungarian avant-garde, despite its fresh dynamic spirit—because of the prevailing circumstances—remained fairly isolated. MA's primary concern was the shaping of a movement for the youth of its own and neighbouring countries, leaning almost exclusively on its own resources, without expecting or getting help, or spiritual support, from elsewhere.

This was the atmosphere surrounding László Moholy-Nagy who was still neither certain of himself nor conscious of his own talents. The start of his career, compared with that of his contemporaries, was also in several respects handicapped. His earliest memories were linked, not with Budapest, not even with a larger town, but with a traditional scattered village, Bácsborsód. He passed his school years in the country, but intellectually lively, town of Szeged. Two

important Hungarian poets, Mihály Babits and Gyula Juhász, and the aesthete, Iván Hevesy, play an important part in his intellectual growth. Later he developed closer relations and friendship with all three. It can probably be attributed to their influence that his first efforts to free himself from bourgeois life lead him in the direction of literature. His verse maintains a wholly dilettante level; on the other hand, in his short stories—which Iván Hevesy published in the Szeged journal, *Jelenkor* (Our Age)—he has already an individual, slightly bitter, tone. Although later he renounces literary activity in the strict sense of the word, his powers of linguistic expression remain. In addition to numerous artistic (and film) articles and books, the film outline of 'The dynamic of the metropolis', written in 1922, exemplifies his literary ability.

'My eyes were not yet trained to see', he wrote later in his memoir entitled *Abstract of an Artist*. 'My approach was more that of "hearing" the picture's literary significance than of seeing form and visual elements. I was conscious neither of these fundamentals nor of the technique of execution. I would not have been able to distinguish between originals, copies or fakes. Then came my discovery of Rembrandt, expecially of his drawings . . . In addition, not having much experience of draughtmanship, but hounded by the desire for quick results, my own drawings seemed to have an affinity with Rembrandt's nervous sketches. The next step was Vincent van Gogh. Again, I was more attracted to his drawings than to his paintings'

From Rembrandt and van Gogh he progresses towards his contemporaries: Kokoschka, Schiele, Munch and Franz Marc. It cannot be known exactly whether it was the literary or the paintierly interest which drew him towards the Hungarian Activists. He takes note of the best: Lajos Tihanyi, József Nemes Lampérth and Bélá Uitz. In the works of all three, he is attracted not only by the characteristic, dynamic strength of line, but by the content lurking behind the line: the tense atmosphere, the social awareness and the expression of personal freedom.

'The regular exhibitions and decisively important movement of the MA set the standard of my works. The debates and conversations I had with Uitz and Nemes Lampérth helped to clarify my errors and to make up my half-thoughts. At that time I used to spend all my money on books of art and I kept on studying pictures, old and new, which got within the reach of my hands and sight', he wrote in 1924 in a questionnaire sent to Antal Németh in Hungary

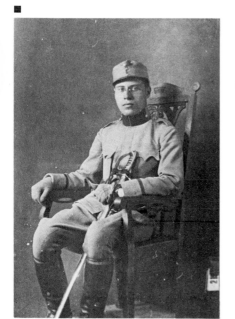

His getting acquainted with Activism coincided with a painful turning point in his life ■ After matriculating, he registered as a law student at the University of Budapest and was soon called up as a soldier. Although only a few sentences in his memoirs are devoted to wartime vicissitudes, this series of personal experiences obviously transformed his whole personality. Because of the influence of the sufferings he experienced, everyday struggles appeared to him in a more heroic form. His humane attitude was formed at that time.

At the Front the hitherto passive spectator becomes a painter. His artistic career does not begin with pictures—his precise, clear field sketches call attention to his particular capabilities. All at once

Moholy-Nagy

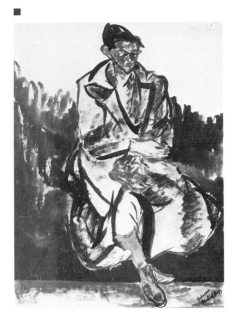

he realizes his gift for drawing and begins to draw tiny, somewhat caricatured, figures—often of soldiers—on field postcards. These sketches show nothing of his real talent but still reveal his easy and skilful touch. Front service, his wound and later the Odessa military hospital mature his outlook; the early water-colours, done of himself or his comrades, date from this period. The outlines are still uncertain, the colours lacking in clarity and he does not know what to do with backgrounds, but the bitter realism of the figures still has its own specific quality ■ *Wounded soldier* 1917.

When he returns home from the Front he is released from further service. In 1918 he takes part in the ex-service artists' exhibition in the National Salon in Budapest—his first public appearance, of which no trace remains. He was disgusted with the war, but neither in word nor picture does he protest against it ● *Hills of Buda* 1918 as did Fernand Léger, who returned from the front at the same time, or the equally pacifist Swiss or Berlin Dadaists. He was attracted by, and often attended, the Galileo circle which was concerned with political problems and linked the best radical intellectuals. He was also drawn by the more and more vigorous activities of the journal, MA. But even then, in his period of becoming an artist, he is an individualist and does not belong anywhere. His only action in communal affairs came somewhat later when, in March 1919, he signed the Hungarian Activists' revolutionary statement—the one occasion on which he plays a role with the Activists in Hungary.

His first fumbling works saw the light in 1916—1917; in 1919 he was already an important artist, having achieved in a couple of years a development which took other important Activist artists a decade.

By 1919 his own style, which is linked only with the Activists, was formed—it has nothing in common with any foreign trend. His landscapes are most nearly related to those of Lajos Tihanyi, both in construction and colour. In fact, however, it is his many portrait drawings rather than his paintings which merit attention. In contrast with the flatness of the earlier water-colours, the lineation of these drawings suffices to render them extraordinarily three-dimensional and alive. The works, with the exception of one water-colour portrait, have no borders or backgrounds. The energies, the tensions, all concentrate within the figures as a result of the density and the thickness of the lines intersecting or covering one another. The silhouettes become clearly and brightly apparent, the inside surface of the body is filled with exciting, tantalising networks of lines from which the folds in the garments develop. The face is always emphasised—sometimes quite clear and bright ▲ *Vorwerk* 1920 sometimes it consists of entangled clusters of lines (Schairer). The networks of lines forming the body and the head have a lively quality of their own—the same structures appear on the artist's barbed wire landscapes as on the clothing of his portraits.

Very little remains of Moholy-Nagy's work at this time—and the picture formed of him can be only one-sided. From this one, known side, he shows himself as an exceptionally forceful, realist artist. Beyond his talent for realism, his interest in transparency is illustrated in the networks of lines with their own lively qualities.

Moholy-Nagy's name never appears in the histories of events of the 1918 bourgeois revolution, nor of the 1919 proletarian one. While

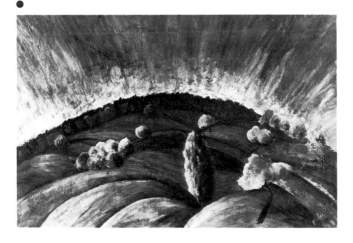

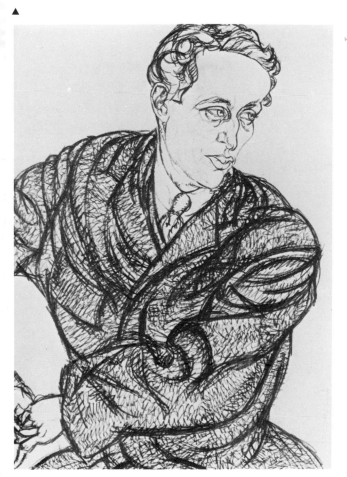

most Activist artists play a leading role in artistic politics at this time, he continues to remain isolated. This peculiar, reserved attitude is characteristic of him as a beginner, perhaps uncertain of himself— later on, while in emigration, he joins wholeheartedly in all communal (non-political) movements. Even at this time, however, he gets a certain amount of acknowledgment: the Artistic and Museum Directorate buys some of his drawings for the collection of the Fine Arts Museum.

After the collapse of the Council of Soviets in December 1919, he arranges, with the Activist sculptor, Sándor Gergely, a small chamber exhibition in the town of his youth, Szeged. His old benefactor, Gyula Juhász, writes several enthusiastic articles about the exhibition. This is his only exhibition in Hungary. In December 1919 he leaves the country with Gergely. He took no part in the formulation of the council's artistic policies and after the fall of the proletarian dictatorship he no longer wishes to remain in his homeland. He arrives in Vienna for a stay of about six weeks, then settles in Berlin, where his real artistic career develops. Even here his Activist period, oddly enough, does not finish immediately. His first Berlin exhibition features expressionist, figurative illustrations prepared for Hasenclever's work 'Man'. Perhaps the most beautiful of his portrait drawings were created in Berlin at the same time as, and in parallel with, his Dadaist works. At the turn of the year 1921 his figurative period comes to an end, returning from time to time in his photographs which are surprisingly realistic and full of vitality.

Moholy-Nagy's vision of unity

by Terence A Senter

Introduction

Numbers inset in text refer to bibliography to be found on page 23; reference number followed by page

'Are you contemporary?'

the New York Saturday Evening Post asked its readers in July 1943, and invited them to check their minds 'against Moholy-Nagy's, a modernist who is so far ahead that he is almost out of sight' *43, 16*. Earlier, in 1935, Herbert Read had described him as 'one of the most creative intelligences of our time' *37, 151*. Since Moholy's death in 1946, his perception of the world has survived through, among others, Marshall McLuhan, and a series of books on Art by Professor Gyorgy Kepes, of Massachusetts Institute of Technology. Moholy has been recognised as a pioneer of abstract art, kinetics, conceptual art, as well as present attitudes to the media of painting, photography, film, typography, three dimensional design (exhibition, theatre, and product), Art and Design education, and as helping in achieving the respect accorded to commercial art. Yet his name and works are relatively unfamiliar in this country, except, perhaps, for the distinguished Parker '51' fountain pen which is still being used by many, oblivious of the identity of its designer.

This, the first, major exhibition of Moholy's work in Great Britain, sets out to demonstrate the wide variety of compatible works that could issue from his fundamental, highly integrated vision. The emphasis is on the European years, with many examples from the relatively little known English period, although rare archive photographs have to assist in conveying the many lost, original paintings. Thus, this period can display some idea of his enterprise, tested to the full as a refugee in a foreign country in the midst of economic depression, and fresh to the language. A token demonstration of his idiomatically American works serves to demonstrate his Chicago period. This essay concentrates mainly on his increasing creative vocabulary of the formative years, 1919—1923.

For Moholy, as artist and educationalist, unity of experience was fundamental, not in mystical, but in firmly practical terms. At his untimely death in America, he still bore witness to the Goethe tradition of regarding life itself as the Art-work, and aesthetic activities as ingredients, when he confided to a friend **'I'm not sure how my paintings will be judged in future. But I am proud of my life'** *33, 26*.

Moholy-Nagy

Moholy's common departure-point was the basic interaction between Man, the organism of biologically finite senses, and his surroundings, that could be manipulated to provide him with ever new ('productive') experiences:

> '**It is a basic fact of the human condition that the functional apparatus craves for further new impressions every time a new exposure has taken place. This is one of the reasons why new creative experiments are an enduring necessity. From this point of view the creations are valuable only when they produce new, previously unknown relationships**' *4, 30*

Anything short of this, he regarded as mere 'virtuosity'. Whatever the medium, the new experiences would not be facile or modish, but the awareness of every healthy human being would be naturally predisposed to benefit from them. The expressive forms had, therefore, to be objectively valid, and not obscurely individualistic: democratic, instead of élitist art-for-art's-sake. Consequently, Moholy sought to serve the public of the industrial age as '**an anonymous agent**', exploring the potential of his pervading interest, Light, through the geometric shapes, typical processes, and synthetic materials of mechanisation, guided by drastic reduction of his media to their most elementary condition and promptings. From there, he went on to envisage an ambitious quest that was to provide his self-declared, fanatical drive as artist and teacher: '**Abstract art, I thought, creates new types of spatial relationships, new inventions of forms, new visual laws—basic and simple—as the visual counterpoint to a more purposeful, cooperative human society.**' *14, 76*.

At first, the quest was identified as '**the new vision**', but later, more dynamically, as '**vision in motion**'.

Development of Moholy's outlook

'Art and Technology—a new unity'
Walter Gropius

1914
**Love and the dilettante artist
(dedicated 'to Panna')
by László Moholy-Nagy** ■

Little girl, you mean so well—
Hot kisses, the treasure of love—
A tired child, I fall into your lap.
Guard me well, little girl, guard my love.

I swam in the Danube this afternoon
And I forgot all about you.
Longing for the old ecstasy—light.
The waves rushed against each other
And my paper heart filled with wonder.
I was gazing at Buda.

How beautiful was Buda this afternoon,
Under a cover of light
A tender silken cover of green, a shroud of bluish mist.
Cap-like it leaped, glowingly, from spire to spire.

By 1923, when the architect, Walter Gropius, appointed him to his Bauhaus school of modern design as head of both the Preliminary Course, and the Metal Workshop, Moholy had already determined his own course as an artist. His marked adaptability and reflective experimentalism, fusing many, and, at times, seemingly incompatible social, industrial, and artistic tendencies, were much in keeping with Gropius's view of all the arts as a broadly based, but united entity. Thus, Moholy had been a very eligible candidate to realise Gropius's ripened Bauhaus demand for 'Art and Technology—a new unity'.

To appreciate the scope of Moholy's outlook at this stage, requires some consideration of his salient, earlier experiences, and their concretion. The works that testify to his evolving thought present their problems. In the absence of any complete catalogue, there is the question, firstly, of chance remains from the Hungarian period, and how representative these survivors are; secondly, of casual, subsequent losses, and wilful, Nazi destruction, including, according to Sibyl Moholy-Nagy, 'about thirty canvases and metal constructions' of his 'earliest work, representing the transition from representational to abstract painting, *32, 133* and thirdly, of the dating issue, since the intricacies of his chain of reasoning, and rapid development are difficult to assess when dates are missing from works and records, and even when the sequence within a known year of production is indeterminate. Undoubtedly, in 1934, he placed an obligation on the spectator to **'grow along with me, equally, and in my place, with each picture', 'to understand their reality',** and their **'complete preoccupation with a problem',** goals that, he believed, would probably make them appear monotonously similar to the uninitiated (October 9th, Moholy to Sibyl Moholy-Nagy, *18*).

Moholy's central, artistic theme, Light, presented itself while he was still exclusively a writer ■ In expressionist poetry of 1914, Love and the dilettante artist, and 1917, Light vision, he moved from a hedonist delight in its local beauty to an abstract meditation on its eternal, interdependent role in Einstein's unsentimental universe, and its creation of what he called **'the new man'.** Parallel with this move, his contemporaneous, early, wartime ventures into design

Moholy-Nagy

took him from the decidedly functional practicalities of map drafting (a task he continued to respect as witnessed by his regard for Horrabin as England's greatest artist in the 1930s) to expressionist crayon drawings and watercolours built on a dynamic, rhythmic interplay of curves, a structural approach that invites comparison with his established thinking in poetic metre. The **Landscape with barbed wire** c.1917 ■; **Wounded soldier, Odessa** 1917 private collection. Budapest; and **Self-portrait** c.1919, powerfully demonstrate the fruits of this tendency, nurtured on the example of Van Gogh, Rembrandt, and contemporary Hungarian MA 'Activists' (see chronology).

The Art Directorate of the short-lived Hungarian Council of Soviets, March 21st—July 31st 1919, was certain enough of Moholy's socialist intentions to purchase three of his drawings. Moholy-Nagy's fundamental conviction about the social necessity of Art emerged as his justification for feeling free to become a painter during the Soviet Council's demand for manpower to effect Communist reconstruction. He felt that, by projecting himself, his sincere and thorough understanding of his own life, and his '**building power, through light, colour, form**", he could give '**life**' as a painter, and provide a biological necessity '**beyond food**' 32, 12. In Germany, a year after the founding of the Hungarian Soviet, he was to mourn its betrayal of '**the spiritual and material needs of the wanting masses**', by a brand of disguised capitalism that merely shifted the power, but ignored the culture:

'A truly revolutionary new system would differ in all aspects from the familiar old pattern. It would eliminate first of all cagelike houses in slums, dead museums that glorify a false world picture, hospitals run for profit that kill patients with ignorance and greed and are actually morgues, the brothel parties of the high officials who buy women, the theatres and operas that stink of ethical foot-and-mouth disease, the constrictions upon creative opportunity in schools which reward only caste spirit' 32, 14

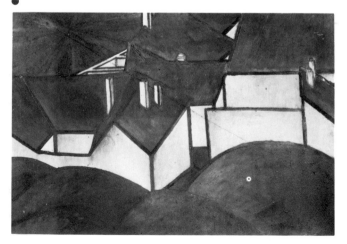

In his key oil-painting, **Landscape with houses** 1919 ● the outlined objects continue his bold, curved rhythms in the hills, but there is forceful contrast with the angular play of the houses. Curved and straight lines become united in the radiating feature at the upper left corner. The sombre colour, simplifications, and planal emphasis demonstrate the impact of Analytical Cubism that Moholy had just begun to explore. But more significant for his future programme is the exposed tension between the flatness of the canvas and the presence of symbols imitative of the third dimension, a tension revealed by Cubism when it rejected what it regarded as the severe limitations imposed by the Renaissance perspective tradition on the painter's apprehension of his subject. Whilst Moholy's hills are illusionistically modelled in chiaroscuro, the network of bold outlines draws attention to the surface division, emphasised by the rudimentary houses at the right, arranged parallel to the picture plane, the prominent counter-perspective distortion of the central wall, and the spatial ambiguity of the upper left corner feature, which seems to waver between a tilted and upright position.

In 1919, too, he blatantly abandoned any vestiges of an underlying perspective structure in favour of a Futurist interaction of scattered symbols, in his lost drawing, **Épits** (Build! Build!) ▲ fusing

wheels and bridges from the active, industrial age, and consistent, verbal slogans, a theme possibly prompted by the Hungarian Soviet, and his role as social servant. Along with industrially functioning geometry (wheels, bridges, gantries), appear curved and straight lines, singly, or in rhythmic clusters, released from any representational duty, combined with triangles, circles, and the mathematical infinity-symbol∞. Now, Moholy identified lines as **'diagrams of inner forces'** *14, 71*. The direction of every symbol, and the extent of completeness, especially of the wheel, were varied. Likewise, the lettering of *Épits* was diversified by the use of both upper and lower case, by direction (up, across, oblique, curved), strict and loose formation, and both conventional and mirrored order (lateral inversion). Super-imposition of the elements, reinforced by long, traversing lines brought coherence to the image. Here, in instinctive, embryonic form, are many of his subsequent, abstract hallmarks.

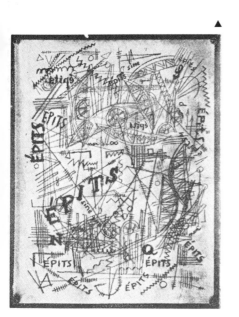

Moholy has recorded that when he turned his attention to colour, he began by making collages with coloured paper strips to observe how they interacted as forces with potent spatial and emotional properties. Hilltop views of the landscape divided into a multiplicity of strips prompted his paintings of similar forms that he called 'acres' (eg **Hungarian fields,** *1919,* formerly Galerie Zwirner, Cologne). The formal groupings are in keeping with the treatments of Landscape with houses and Épits, ranging from plain, geometrically precise forms in regular regimentation (invoking his conscious opposition to conventional prejudices against the artist's use of ruler and compasses) to looser examples employing speckled areas reminiscent of his later woodcut treatments. The clustering stresses the cellular surface structure. Subsequently, this type of basic strip was refined to provide Moholy's elementary unit for spatial play in abstract works that set out to confound the spectator's expectations established by Renaissance values. Twenty-five years later, in a spirit of self-discovery, he was to look back even on all the shapes that he had used during that time as variations of a ribbon (strip), and to include diagrams of full, and segmented circles, presumably, as continuous strips between centre and circumference *14, 77.*

His direct preoccupation with the mutual interplay of basic shapes, and, notably, his occasional conspicuous fusion of diverging trends in his own imagery, point to his search for standard, objective laws of forceful, pictorial cohesion and concentration. Thus, **f in field** *1920* collage and watercolour, and **Great fields and bridges** *?1919,* oil, reconcile his symbols from 'acres' and industry. The 'f' possibly derived from the German word 'Feld' just as later compositions (eg **Yellow disc. Typographical picture of the name, MOHOLY,** *1921,* Jewett Arts Centre, Wellesley, Mass; and the photocollage of his Bauhaus role, **Me,** *1925,* lost), continued a tradition of calling on inherent imagery of various kinds, traceable back to Épits.

The lure of Germany's 'highly developed technology', that, on his own admission took Moholy to Berlin, guided his course there, and the cosmopolitan, artistic cross-currents at this hub had an immense, catalytic effect on the development of his schema. To his own advantage, he rode the volatile relationship between the Dadaists and Constructivists, establishing a wide circle of contacts. This made him valuable to Lajos Kassák, not only as Berlin represen-

Moholy-Nagy

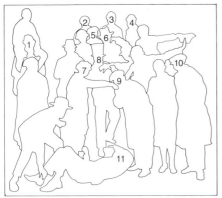

The constructivist dadaist congress in Weimar 1922

Constructivists
1 Max Burchartz
3 Alfred Kemény
4 Moholy-Nagy
5 El Lissitzky
6 Cornelius van Eesteren
8 Theo van Doesburg
11 Hans Richter

Dadaists
9 Tristan Tzara
10 Hans Arp

Lucia Moholy (2) and Mrs Nelly van Doesburg (7) also attended the congress

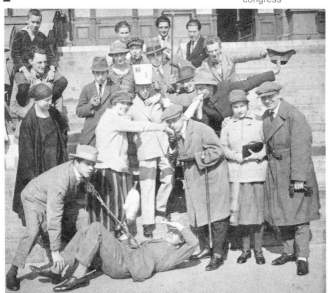

tative of his Hungarian, avant-garde Art periodical, *MA,* exiled in Vienna, but also as joint editor of the **Book of new artists: Buch Neuer Künstler,** *1922,* for which Moholy assembled all 108 illustrations during its preparation from 1921. Significantly, Kassák later described this book as 'the first attempt to demonstrate the intimate and mutually beneficial correlation between Painting, Sculpture, Architecture, and Technology' *1, 99,* although one or two of the contents resist this intention.

The intricacies of relations and ideologies among the avant-garde in Germany from 1920 to 1925 make the tracking of Moholy's creative path a fraught issue. The raising of the Allies' economic blockade of Russia in 1921 brought the Constructivist El Lissitzky to Berlin at the end of the year, and the first, great Russian art exhibition to show Revolutionary trends, in January 1922, indicating the split between the Productivists (eg Tatlin, and Rodchenko) and the spiritual, non-utilitarian element (eg Malevich and Gabo). Lissitzky could write early in 1922 of 'the new collective, international style' as a 'product of communal creation', established by an inherent human compass, unaffected, for example, by Russia's seven-year isolation, although preserving local 'characteristics' and 'symptoms' *28, 340-341.* His area of vagueness between the 'universal' and the 'individual' left much room for opportunist manoeuvre. Similarly, Van Doesburg, the crusading, dogmatic advocate for Dutch Constructivism, De Stijl, arrived in Weimar in 1921, and actively fought to reform the Bauhaus of its mystical 'Mazdaznan and the production of individualistic art', as he later explained to Moholy *19, 43,* represented by the initiator and first head of the Preliminary Course, Johannes Itten. Itten's own work was Dadaist, and his teaching approach, expressionist. Whilst, in 1920, Van Doesburg declared support for Dada's anti-art iconoclasm in preparing civilisation for what he called 'the New Vision's happiness' *19, 39,* he was himself later taken to task by Moholy for his secret Dada alias, I K Bonset, uncovered in October 1922, when Dada was regarded as having outlived its purpose *17, 315.*

Enough common interest had existed between Dada and Constructivism in October 1921 for Moholy to sign the Elementarist Manifesto with Raoul Hausmann and Arp, and Ivan Puni, a recent arrival from Russia, who had worked with Tatlin, had been a declared Suprematist follower of Malevich, and thus had had a direct experience of the two basic viewpoints of pure creativity and the artist-engineer. Their manifesto called for the renewal of perception via a styleless, pure Art, facilitated only by the energies at work in the present, and finding form through the medium of the artist, unrestricted by objectives of utility or beauty. Schwitters' surviving correspondence of September 24th 1922 leaves no doubt that the Moholys were guests of the Dadaists ■ (Arp, Tzara, Doesburg, Schwitters, and Hausmann) during evening performances at Weimar, Jena, and Hanover. Also, as late as Winter, 1922—1923, Moholy himself had been 'inspired' by poverty and cold, whilst sharing a Berlin attic studio with Schwitters, to follow his example and use inflationary banknotes as a cheap medium for collages (eg **25 Pleitegeier,** Bankruptcy vultures, 1922, formerly, Galleria Martano, Turin). Moholy had known Hausmann from 1921 and this contact, together with his own Dada act of cutting up and completely

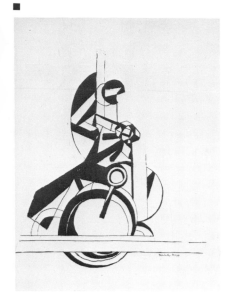

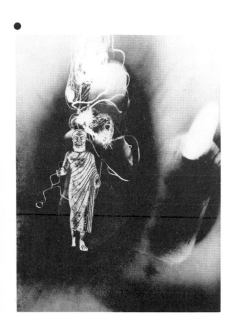

rearranging the elements of an already finished still-life ■ *Der Rad-fahrer, 1920,* Kunstmuseum, Düsseldorf) (and his construction of 1920 of his 'own version of machine technology, assembled from the dismantled parts' that he had found on his walks) were early signs of the thinking that helped him towards the use of photomontage, and, from 1922, the photogram *14, 72*. Moholy's note on the reverse of a photogram of May 1928, signifies a Dadaist transformation of the objects used: 'what a sunbeam and a little imagination can make out of a grater' (Larson Collection, U.S.A.). The fusion of photogram and photomontage is seen eventually, for instance, in *Zeus has his troubles too 1943,* location unknown ●

All these artists belonged to Berlin's radical November Group (established 1919, with messianic zeal by the Expressionists, inspired by Kandinsky's pre-war writings, and named after the birth-date of the new Weimar Republic). Moholy's policy, to protect the free growth of his vision amidst this excited activity, by avoiding restric-tive moulds, is clearly stated in his letter to Paul Westheim of July 1st, 1924, answering charges of eclecticism, plagiarism and self-promotion, brought by his renegade associate, Kemény, who, by contrast, had singled out only himself and Péri in 1922 as comparable to the greatest Russian artists. Moholy declared:

'But I am totally uninterested in whether or not Mr Kemény questions my originality; whether he or anyone else labels me Suprematist, Constructivist, Functionalist, etc...Classifications are born by accident, through a journalistic quip or a bourgeois invective. The living force of artistic development changes the meaning of the term without giving the artist a chance to protest his false identity' *32, 43*.

Later, he expanded on this by speaking of the influence of 'Schwit-ters' 'Merz' painting and Dadaism's brazen courage' on him *14, 72*. In 1925, El Lissitzky sided privately with Kemény, making highly subjec-tive accusations against Moholy on the basis of competitive, indi-vidual originality, implying that he was denied the very right to respond to the climate of new, collective internationalism that Lis-sitzky himself advocated *28, 66-67*. El Lissitzky's claim to have fed Moholy his ideas about production and photography in 1921—1922 were strongly denied later by both Moholy and his wife, Lucia. In turn, El Lissitzky was to be accused of plagiarising Malevich by Ludwig Hilbersheimer, an architectural teacher at the Bauhaus during Hannes Meyer's administration, who had met Malevich in 1927, and, presumably, based his judgement on Lissitzky's abrupt change of allegience from Chagall to abstraction in 1919 *29, 9*.

As early as July 1922, as a member of MA, Moholy had rejected the individualistic emphasis at the Düsseldorf Congress, and declared that Art should **'find ways to work with new means and practitioners on a collective, non-restrictive basis'. . . 'to fulfil the objective demands of this age'** for the **'positive life'** of **'a future collective society'** *27, 186-187.* His idealistic, political comment became more directed and vehement from late 1922 to early 1923 with calls for the education of the working class to the evil, not of the machine, but of social organisation, and a joint declaration (with Kemény, Kallai, and Péri) in the Communist, Hugarian, Constructi-vist journal, *Egység* Unity, *1923*, published in Berlin, warned about an

Moholy-Nagy

increasing bourgeois trend in Constructivism, both in De Stijl's aestheticism, and in the Russian Obmokhu Group's 'technical naturalism', which contradicted any real Proletcult policy for 'a proletarian and collective art of a high standard' *36, 176* and *35, 77.* 'Technical monomania' was his subsequent term for this Russian Constructivism, although he allowed for this 'interest' as 'surely sound' if seen as a transitional stage from 'dry musty conceptions of 'art'' *6, 132*.

When Moholy and Kemény delivered their manifesto on **The Hungarian man** (Berlin Constructivist Congress, possibly Spring, 1923), they provoked Hausmann's opposition to what he regarded as its limited, rigid character *35, 76-77*. Hausmann's spirited reply, in the form of his **Second PREsentist declaration** (co-signed by Viking Eggeling; published MA, 1923), confronted the incomparable sense co-ordination of the brain, its total time-space grasp, and dynamic perception of Nature, by the mere approximations of machinery and the technologically-inspired logic of Constructivist 'play'. Although it attacked Moholy's social commitment, nevertheless, its biologically-directed course of 'universal obligation to the physical and psychological problems of nature and men', healthily sceptical about the authority of any individual specialism, became developed as a vital springboard for Moholy's thought. In his first Bauhaus Book, **Painting, Photography, Film,** he was to pay tribute to the **Optophone** *1927* an outcome of Hausmann's insight and 'bold imagination', which, he felt, promised a scientifically-grounded union of light and sound *4, 22*.

Teaching and industry

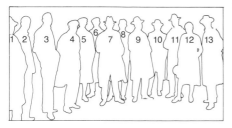

The Bauhaus staff 1926

1 Albers
2 Scheper
3 Muche
4 Moholy-Nagy
5 Bayer
6 Schmidt
7 Gropius
8 Breuer
9 Kandinsky
10 Klee
11 Feininger
12 Stölzl
13 Schlemmer

Gropius, who met Moholy in Berlin in 1922, had been 'impressed by the character and direction of his work'. However, at that stage, Moholy was little closer to Gropius's later claim about his criteria for appointment ('bound to be intimately acquainted with factory methods of production and assembly' *24, 53*) than other Bauhaus masters, such as the Expressionist painters, Klee and Kandinsky ■
In fact, in 1922, provocation from Itten had led Gropius to reaffirm his goal of 'unity in the *fusion*' of the 'two entirely separate processes of design: 'private individual artwork and the public world of industry *44, 51*. Until the Bauhaus could fulfill the need for proficient, creative industrial designers, its own workshops had to operate under the joint supervision of a technical, and a 'form' master. Gropius referred to, among others, 'the new Hungarian schools' as representing the way young artists were beginning 'to face up to the phenomena of industry and the machine', by trying to design 'the "useless" machine'. His Bauhaus tenets aimed...

■
'to replace the principle of division of labour with that of unified

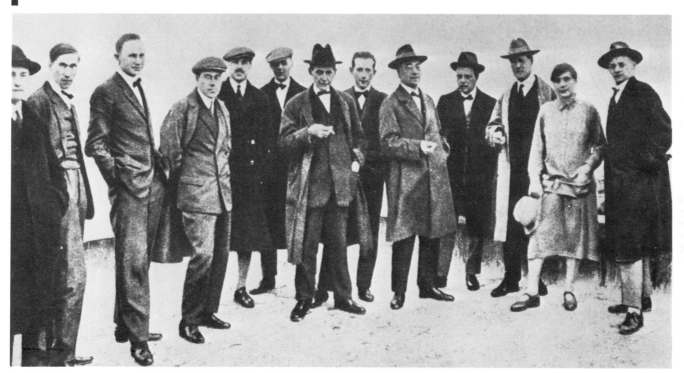

collective work, which conceives the creative process of design as an indivisible whole', and to educate 'people to recognise the basic nature of the world *in which they live*'.
He called for 'typical forms that symbolise that world', not self-conscious styles or dogmas of art-for-art's-sake, and referred to recent news of the worthy Russian example of a similarly broadly-

Moholy-Nagy

■

The freedom that he assumed in his struggle for the universal could be difficult for others to tolerate, even at the Bauhaus. Thus, Xanti Schawinsky, a Bauhaus theatre student who spent his first term in 1924 with him, has disclosed (1948) that Moholy's enemies resented him out of feelings of jealousy or persecution, believing him to have stolen their ideas; Albers had been particularly angry when he thought he detected his own, unpublished ideas in Moholy's writings. Occasional squabbles are said to have resulted. Schmidt and Bayer appear to have had reservations about him, and Schawinsky claims to have prompted Moholy into designing a jointless chair after telling him of Albers' reduction of the usual thirty-six joints to only eight. Furthermore, Schawinsky believed that Moholy appropriated his own theory of a new, model theatre for publication. However, as Schawinsky admitted, the truth would be difficult to establish, and emphasised Moholy's perpetual concern for 'the whole movement', and his probable assumption that the specific sources of slogans were of secondary importance. Schawinsky felt that Moholy was most precisely revealed by Gropius when he declared that 'the new ideas depended above all on him to be made known, instead of rotting in the drawer' *45*. Later, in 1936, Moholy found the tables turned, when as the sole subject of *Telehor,* he and its editor, Kalivoda, were taken to task by Gropius for disregarding 'the anonymous breadth of movement' and 'power' in contemporary painting by having concentrated on an individual rather than presenting 'the cross-section that is so necessary for us'. (Gropius to Kalivoda, March 14th 1936 *44*).

based, but integrated, curriculum, which went so far as to recognise 'music, literature, and science as coming from one source...' Presumably, Gropius had Moholy very much in mind when he continued by recognising these makers of 'useless' machines as orienting themselves with the 'compass of the future' to overcome the machine's 'demon' *42, 51-52; 24, 92'*, since he appointed him to replace Itten in Spring 1923; from that point, Moholy's 'neutral' forms were reflected in Bauhaus imagery, and his outlook became a burning issue there.

Although he continued to paint, Moholy's aggressive belief in **'the dawn of a new life'** *4, 45*, with the victory of photography over painting, temporarily upset the Bauhaus painters, Klee and Feininger, but Schlemmer, master of the stage workshop, observed late in 1925 that Moholy had become Gropius's 'Prime-minister', and that 'his influence at the Bauhaus and in the Art-world' was 'great, even colossal' *39, 84*. Earlier in 1925, Feininger, an opponent of Gropius's view of a unity between art and technology, deplored the way he considered Moholy's influential 'opinions' as 'the most important at the Bauhaus' and Moholy himself as 'the only person of practical importance' *42, 97.* In keeping, Gropius declared later that much that the Bauhaus accomplished stood to Moholy's credit *14, 5.* As co-editor with Gropius of the Bauhaus Books, Moholy was able to influence a decisive aspect of the Bauhaus identity and heritage in the choice of subjects and authors. After Nazi closure of the Bauhaus, he characterised the series as 'the only authentic records of fourteen years of educational work'. *12, 5.* Fourteen of a promised forty titles appeared, before the editors resumed the idea in the mid-1930s. Their publishing blurb of 1927 spoke of covering art, science, and technology problems, and explained their advent as motivated 'by the recognition that all areas of design are interrelated' *42, 130*. In one of these two volumes, **Painting, Photography, Film** Moholy identified two channels in the struggle to regain a universal art, rooted in collective life, and biologically-based, rather than a self-contained aestheticism. Firstly, there was the alleged purifying of **'expressional elements and means'** by Cubism and Constructivism, and, secondly, the **'Gesamtkunstwerk',** that traditional desire for a universal, total work of art that lay at the heart of Gropius's original conception of the Bauhaus, powerfully advocated in the 19th century by Richard Wagner, whose hopes for such a unity of expression, spurred by 'inner necessity', were outlined in his essay, **The art work of the future** *1849*. But Moholy felt that such a 'sum of all the arts', associated with de Stijl and 'the first period of the Bauhaus', was understandable as a countermeasure to fragmenting specialisation in all fields, but was now outdated, and called for a more encompassing **'synthesis of all the vital impulses spontaneously forming itself into the all-embracing *Gesamtwerk* (life) which abolishes all isolation, in which *all individual* accomplishments proceed from a biological necessity and culminate in a *universal* necessity'** *4, 16-17* ■

Echoes of the Russian split between pure painting and Production can be discerned in Gropius's remarks about the makers of 'useless' machines. Although Moholy, like Rodchenko, produced useful graphic-design, only later, in Chicago did he turn to industrial

design, 1944. Frequently, he is on record as having considered himself primarily a painter, and whilst he was at the Bauhaus, he sternly applied his aesthetic demand for 'simple basic shapes, cylinder, cube, cone', in the design, for example, of glass milk jugs *20, 282*. In his attempt to restore parity among the design areas, Gropius had initially banned painting at the Bauhaus, but was eventually persuaded to allow it as an unofficial part of the curriculum. He had also tried to guarantee the survival of the Bauhaus against hostile, outside opposition by making it apolitical, so accounting for Rodchenko's remark of 1928 about Moholy's 'former' leftist position. In practice, however, the Bauhaus was leftist. Schlemmer's letters indicate the irony for Moholy and Gropius when a sector of Communist student-representatives, motivated by Hannes Meyer (who had arrived in 1927 as master of architecture and eventually was to succeed Gropius), began to scour the curriculum for what they deemed 'unacceptable' and 'unnecessary' teachers. Schlemmer noted that Meyer liked Moholy's paintings, but disliked his 'human-productive' character and his allegedly 'wrong teaching' which, he claimed, the students wisely rejected *39, 91 and 100-101*. Later, after enforced dismissal, Meyer wrote of his abhorrence for the contrived, geometric style, and primary colour, plus tone, that, for him, characterised the Bauhaus in 1927, and represented inbred theories of art stifling any attempts at 'right living'. Furthermore, in a broadside at Moholy, he talked of 'the younger generation' which cast sly glances at the Left yet simultaneously hoped some day to be canonised in that very same 'temple' of cult art *42, 164*. After a violent quarrel with Meyer, Moholy resigned (January 17th, 1928), giving his reason as the unacceptable, overriding new criterion of efficient, vocational specialisation, instead of the original balanced 'development' of the whole 'man' *32, 46-47*. Gropius, too, resigned on February 4th *42, 136*. Subsequently, Moholy and Gropius, who remained lifelong friends, attempted unsuccessfully to revive the original Bauhaus idea in artistically isolated England in the mid-1930s, before finding more encouragement in America.

Moholy's freelance, commercial experience (Berlin, Amsterdam, and London, 1928—1937), together with his need to learn Dutch and English, provided the severest test of the practicability of his Bauhaus ideals. His vision of unity persisted, and in London on December 16th 1935, he informed Gropius of the way typography fitted into his future plans: ●

'I do typography *too*, because I want to prepare a unity of all graphical techniques in the future, in the *preassembly* of the objects to be 'printed', and I regard the present type of advertising prospectuses, pamphlets, posters, etc. as the best preparation for that purpose' *44*.

This idea of a technical depository is given special clarity by his personal prediction of 1939 that, all our endeavours and the work of the former Dadaist, Raoul Hausmann, point in this one direction—we shall have one day, our optophonetic art, which will allow us to *see music* and hear pictures *simultaneously' 11, 31*. In addition, **Vision in motion** referred to the futurist-inspired job of modern newspapers to design layouts so that **'the reader should read all the news almost at once'** *17, 307,* and, assuming that the mind's capacities were still

largely untapped, declared the need for visual space-time symbols, such as the spiral, which, **'by future research...will help to clear and shortcut communicational needs on the plane of intellectual-emotional fusion'** *17, 256*.

Despite enormous financial problems, Moholy selflessly devoted himself in America to the new vision and Bauhaus idea of the design student's process of natural (organic) discovery, although charges of dabbling came from the powerful purveyors of built-in obsolescence. Moholy appears to have regained his own equilibrium now that, once more, he was in possibly the only occupation that would allow him freely to extend his vision, and to test its promptings. He taught Raoul Francé's biotechnique, 'an attempt at a new science', which had abstracted a basic vocabulary of forms and designs from Nature, for use in designing technical appliances. He sought solutions to cater for the still obscure psychological factor, rather than stopping short, as earlier, at labour-saving devices for only physical comfort *9, 23-24*. If some students should become 'free' artists, (and art was 'valued by the [new] Bauhaus educators as the highest aim in life and as the highest expression of a cultural period'), this, he maintained, would be incidental to their training as designers and craftsmen to **'make a living by furnishing the community with new and useful ideas'** *10, 6*. Montessori's educational approach to developing sensory experience by self-motivated discovery is implicit in his methods, and he favoured Pestalozzi's notion that, 'not knowledge but the ability to acquire knowledge is the task of education' *27, 26*. In 1946, he wrote that his first year design-exercises were correlated by **'the method of simultaneous handling of the same problem'** whereby, for example, a sculpture made in the modelling workshop would serve for further analyses in photography, mechanical drafting, drawing and colour analysis, and science and technology classes, in order to emphasise the mutual influence of technique and materials *16, 71*. American students impressed him in 1937 as much more eager to learn and understand than European *46*. His priority became the training of designers to be aware of broad, interacting world developments, to provide them with a farsighted, flexible approach and readiness to evolve. The move towards the abolition of production-line drudgery, by the automatic production of one-piece objects in 1943 was a case in point *43, 89*. A broad course of academic subjects, angled for design-students, was contributed by specialists from the University of Chicago.

The ultimate test for his 1929 slogan, **Everyone is talented 6,14,** came with his rehabilitation programme for returning, wounded servicemen, which he extended to all handicapped, placing the emphasis on objective, productive goals far from the customary, patronising approach that affronted the subject's dignity. Exercises, such as texture-charts for the blind to sharpen other senses, provided a decisive application for his original Bauhaus Preliminary Course of the 1920s.

In 1934, he summed up what may be regarded as his own uniqueness in this century when he expressed his opposition to the **'cowardly maxim...that intellectual attainments are damaging to the artist, that feeling and intuition alone are required for the task of creation'**, and pointed to his great supporting example of the Renaissance *8, 31*. Certainly, in America, his staff could be at a loss when Moholy was absent. In 1946, Herbert Read visited Moholy's Institute of Design in Chicago, and judged it 'the best school of its kind that exists in the world today' *42, 584*. Five days after Moholy's death Read wrote to Jack Pritchard, one of Moholy's decisive friends and patrons in England, regretting 'the end of a great experiment', and concluded that 'no one can replace Moholy' *46*. Even their deep division over whether art inaugurated new historical eras and gave clues to changes in other fields of civilisation, as Moholy believed was settled in 1953, when Read had worked his way round to its acceptance (in his book, *Icon and idea*) *25, 8: 38, 221*.

Moholy's distinctive legacy has been his challenge for us to see wholeheartedly through 20th-century eyes, a call associated during his lifetime with a charismatic, exuberant personality, affectionately remembered by Pritchard as that of 'a delicious madman'.

Terence Senter is at present preparing a book on Moholy-Nagy's English period

Select bibliography

The following, major references are indicated in the introductory essay **Moholy-Nagy's vision of unity** and catalogued by a first numeral, indicating the appropriate item, and a second, the relevant page.

Works by L Moholy-Nagy

1 with Kassák, Lajos *Buch Neuer Künstler* Vienna 1922. Facsimile, Budapest, Corvina Verlag/Magyar Helikon 1977, with postscript by Éva Körner

2 with Schlemmer, Oskar; Molnar, Farkas *The theatre of the Bauhaus* Connecticut, Wesleyan University Press 1961 (English translation, with some pictorial modifications, of *Bauhaus Book 4, Die Bühne im Bauhaus.* München, Albert Langen Verlag 1925)

3 *geradlinigkeit des geistes—umwege der technik* bauhaus 1, 4. xii, 1926. (directness of the mind—detours of technology)

4 *Painting, photography, film* London, Lund Humphries 1969 (English translation of Bauhaus Book 8, Malerei, Fotografie, Film. München, Albert Langen Verlag 1927, 2nd edition)

5 *fotografie ist lichtgestaltung* bauhaus 2 jahrgang (1) 1928 (photography is construction with light)

6 *von material zu architektur* (Bauhaus Book 14) München, Albert Langen Verlag 1929. Facsimile, Mainz and Berlin, Florian Kupferberg 1968

7 *Lichtrequisit einer elektrischen Bühne* Die Form, Berlin, v5, pt11-12 (Lighting requisite for an electric stage)

8 (Kalivoda, Fr. ed) *L Moholy-Nagy. Telehor 1-2,* Brnö, 1936

9 *The New Bauhaus and space relationship* American Architect and Architecture, New York, December 1937

10 *New approach to fundamentals of design* More Business, Chicago, November 1938

11 *Painting with light—a new medium of expression* Penrose Annual, London 1939

12 *the new vision* London, Faber 1939 (Tr. Daphne M Hoffmann)

13 *About the elements of motion picture* Design, Syracuse, October 1940

14 *the new vision* 3rd rev edn, and abstract of an artist (1944) New York, George Wittenborn and Co, 1946 4th rev edn, 1947, reprinted 1961

15 Space-time problems in art. In *The world of abstract art,* New York, American Abstract Artists 1946

16 *New education—organic approach* Art and Industry, London, March 1946

17 *vision in motion* Chicago, Paul Theobald and Company 1947, reprinted 1965

18 *L Moholy-Nagy* Archives of American Art, Smithsonian Institution, Washington (Appropriate sections have been specially translated from the German)

By others

19 Baljeu, Joost *Theo van Doesburg* London, Studio Vista 1974

20 Banham, Reyner *Theory and design in the first machine age* London, The Architectural Press 1960

21 Cauman, Samuel *The living museum. Experiences of an art historian and museum director—Alexander Dorner* New York University Press 1958

22 Friedrich, Otto *Before the deluge. A portrait of Berlin in the 1920s* London, Michael Joseph 1974

23 Giedion-Welcker, Carola *Contemporary sculpture: an evolution in volume and space* New York, George Wittenborn 1961

24 Gropius, Walter *The new architecture and the Bauhaus* London, Faber 1935

25 Gropius, Walter, quoted in Maur, Karin von *Oskar Schlemmer. Exhibition catalogue,* Spencer A Samuels & Co Ltd, New York, Oct—Nov 1969

26 Kállai, Ernst *Ladislaus Moholy-Nagy* Jahrbuch der jungen Kunst, Leipzig 1924

27 Kostelanetz, Richard (ed) *Moholy-Nagy* London, Allen Lane The Penguin Press 1971

28 Lissitzky-Küppers, Sophie *El Lissitzky: life: letters: texts* London, Thames and Hudson 1968

29 Malevich, Kasimir *The non-objective world* Chicago, Paul Theobald and Company 1959. With introduction by Ludwig Hilbersheimer (English translation of Bauhaus Book II, *Die gegenstandlose Welt* 1927)

30 Malevich, Kasimir *Essays on art* vol 1. Edited by Troels Anderson. Copenhagen, Borgen 1968

31 Moholy, Lucia *Moholy-Nagy:marginal notes* Krefeld, Scherpe Verlag 1972

32 Moholy-Nagy, Sibyl *Moholy-Nagy. Experiment in totality* New York, Harper & Brothers 1950. 2nd edition, MIT, Cambridge (Mass) 1969

33 Moholy-Nagy, Sibyl *Laszlo Moholy-Nagy* In the catalogue, Moholy-Nagy, Museum of Contemporary Art, Chicago 1969

34 Moholy-Nagy, Sibyl *Zur Ausstellung farbige Zeichnungen, 1941—1946* In the exhibition catalogue, Laszlo Moholy-Nagy, farbige Zeichnungen, 1941—1946; Galerie Klihm, Munich, January-May, 1971 (On the exhibition of coloured drawings, 1941—1946) (Appropriate sections specially translated from the German)

35 O'Konor, Louise *Viking Eggeling 1880—1925* Stockholm, Almqvist & Wiksell 1971

36 Passuth, Krisztina *Un esprit inventif*

37 Read, Herbert *A new humanism* Architectural Review, London, October 1935

38 Read, Herbert *A great teacher* Architectural Review, London, May 1948

39 Schlemmer, Oskar *Briefe und Tagebücher* Stuttgart, Verlag Gerd Hatje 1977 (Appropriate sections specially translated)

40 Weiss, Evelyn *Alexander Rodtchenko. Fotografien, 1920—1938* Cologne, Wienand Verlag 1978

41 Weitemeier, Hannah *Licht-Visionen* Berlin, Bauhaus-Archiv 1972

42 Wingler, Hans *The Bauhaus:Weimar,Dessau, Berlin, Chicago* London, MIT 1969

43 Yoder, Robert M *Are you contemporary?* The Saturday Evening Post, New York, July 3rd 1943

Archives
44 Gropius, Nachlasz. Bauhaus-Archiv, Berlin

45 Moholy-Nagy, Sibyl. Archives of American Art, Smithsonian Institution, Washington

46 Pritchard, Jack. Archive. Department of Architecture, University of Newcastle-upon-Tyne

László Moholy-Nagy (left) with his brother Á'kos, Szeged 1912

Moholy-Nagy chronology

1895 July 20, born at Bácsborsod, near Moholy village (the name of which he added subsequently to his own, László Nagy), on a wheat farm in Southern Hungary

1913 Student of Law at University of Budapest

1914 Artillery-officer in Austro-Hungarian Army during First World War. First work in visual design was drafting of army maps
Wrote poetry, including **Love and the dilettante artist.** Admired Dostoyevsky, and wanted to become a writer

1916 A contributor to the periodical, **Jalenkor,** edited by eminent Hungarian art-critic, Iván Hevesy
Wounded in Italy, and confined to field hospitals including Odessa, and Galicia

1917 After receiving little encouragement for his poetry from Hevesy he turned to drawing the war scene in crayon on military postcards, and in watercolour
Definitive poem, **Light vision**

1918 After discharge from the Army, gave up Law studies and began to teach himself Art. Attended evening life-classes, and drew landscapes, figures, and portraits by day. Avidly collected art books

1919 March 21—July 31, The Council of Soviets, an alliance of Socialists and Communists in power in Budapest, looking to the Russian example, with the Russian, Bela Kun in charge of Foreign Affairs. Abolition of private ownership; organisation of Red Guard; votes to all workers and soldiers; all other classes deprived of privileges
By 1919, in Art, first the Nagybánya and 'Eight' Group had reflected Cezanne and Expressionism, then the 'Activists', related to Lajos Kassák's Arts periodical, **MA** (Today), began to show signs of early Cubism. Kassák, who had met Picasso in Paris in 1909, struggled for the removal of the legacy of beauty and goodness from Art and Literature so that they would be free to lead the people from a confused world towards genuine progress, guiding the 'liberated will', encompassing 'the totality of the cosmos', and striving for human apprehension of the infinite

Moholy was stimulated by the exhibitions organised by **MA,** and by advice from Activist painters, Béla Uitz and from József Nemes-Lampérth of the Workers' Training Shop
Three of Moholy's drawings were purchased by the Art Directorate of the Soviet
Although strongly sympathetic to the Soviet revolution, **MA's** expressionist, liberating strategy, and its self-declared non-alignment brought Communist labelling as an 'excrescence of bourgeois decadence'. Moholy searched his conscience about the ethics of becoming a painter when the revolution demanded manpower, but concluded that his art could meet a fundamental social need
The Counter-revolution, prompted by the West, led to the emigration of the Activists, but in Kassak's case, not before a jail sentence. He and Uitz arrived in Vienna in 1920, and continued **MA** from there. In December, 1919, Moholy left Hungary for Vienna after his first exhibition, a joint show at Szeged that month. His freedom to make such a relatively late departure suggests that his political life had been cautious

1920 Met Kassák in Vienna, and, by April, had become regarded as close associate
January—February, left Vienna for the attractions of industrial Berlin. Initially, regarded Kurt Schwitters' Dadaist-Merz collages as pointless and old-fashioned
June 5, First International Dada Fair in Berlin (photomontages, assemblages, and posters), organised by Raoul Hausmann, editor of **Der Dada,** George Grosz, and John Heartfield, against continued tank and shooting activities in the city. The Dadaists went out to confound bourgeois values and corruption by producing biting anti-art. Prosecutions followed, but Hausmann saw that Dada had lost its sting, and, with Schwitters, developed a more abstract tendency over the following two years that he called Anti-Dada and PREsentist

1921 January 18, Moholy married Lucia Schulz, who subsequently shared in his work
March 15, first work published by **MA**
From April 25, German representative of **MA**
September 15 issue of **MA** devoted to Moholy, with eleven pictures and an article

Moholy-Nagy

October. Moholy, the Dadaists, Hausmann and Jean Arp, and the Constructivist, Ivan Puni, who had recently arrived after working in Russia with Malevich and Tatlin, signed the **Manifesto of Elemental Art,** issued in **De Stijl** (IV, 10, 1921), calling for a styleless, pure art of the present

By Winter, Hausmann, and other Dadaists, Hannah Höch, and Hans Richter were regular visitors to Moholy's Berlin studio. When the Allies lifted their economic blockade of Russia, the influential Constructivist, El Lissitzky, Professor of Architecture at the Moscow, laboratory-style art-school, the Vkhutemas, travelled to Berlin, where he became a frequent guest at Moholy's studio. El Lissitzky's activities as widely-travelled speaker, writer and painter, photographer, typographer, and theatre-designer spread the news of the Russian Revolutionary developments to the West

Alfred Kemény, from the fringes of **MA,** and now a Berlin art critic was invited to lecture to Inkhuk (the Russian Communist Institute of Artistic Culture) on 'New directions in contemporary Russian and German Art'

Moholy began to work on abstract constructions in various metals

1922 January. 'First Exhibition of Russian Art,' Galerie van Diemen and Co, Berlin (followed by Amsterdam), covering the period from 1890s to 1922. El Lissitzky designed interior and arranged the works

MA invited Kemény to lecture on Russian Constructivism during a Russian Evening before the van Diemen exhibition

Before May, Moholy's first one-man show at Herwarth Walden's **Der Sturm Gallery,** Berlin. (El Lissitzky gave a review in **Veshch** (Object), no 3, May 1922, Berlin, referring to the Hungarian reflection of Russian Revolutionary productive (utility) art, and to the geometry of Moholy and Péri, distinctive for Berlin, as a transition from canvas to constructions in space and undisguised material)

In Berlin, met Walter Gropius, founder and director of the Bauhaus school of modern design, Weimar, after, apparently, Adolf Behne took him to see Moholy's exhibition at **Der Sturm.** Impressed by the nature and the tendencies of Moholy's work, Gropius offered him the headships of the Preliminary Course, and Metal Workshop

Moholy co-edited the **Buch Neuer Künstler** with Kassak, a conspectus presenting the common denominator in new painting and design. Because of his wide circle of contacts, Moholy was responsible for collecting the illustrations.

October. Moholy and his wife were among avant-garde circle of Dadaists and Constructivists who met at Weimar, temporary home of the host, Theo van Doesburg, the propagandist, painter, and architect of De Stijl, during his campaign to redirect the Bauhaus to mass-production models on De Stijl lines. With others, the Moholys then travelled on to another congress at Düsseldorf. With Kemény, Moholy published the **Dynamic-Constructive Energy-System** in **Der Sturm's** periodical. Responding to Gabo and Pevsner's Russian **Realist Manifesto** 1920, they proposed 'the activation of space' by using materials as conveyors of energy to create tensions which would actively incorporate the spectator

December. Article in **The hanged man** (Akasztott Ember) called **Debate on the problem of the new content and the new form,** advocating the raising of the machine to Art in a drive towards a Communist way of life

1922—1923 Exhibits together with El Lissitzky at Kestner Gesellschaft, Hanover

1922—1923 Winter. Shared a studio with Kurt Schwitters in Berlin. High inflation turned Moholy to following Kurt Schwitters' example in using cheap banknotes to make collages

1923 Early Spring. Moholy attended Constructivist Congress in Berlin with Kemény, Richter, Eggeling, Hausmann, Gabo and Pevsner. Moholy and Kemény delivered their manifesto on **The Hungarian man**

Produced his first painting on plastic sheet

Moholy, Kemény, Kallai, and Péri issued a Declaration in the illegal Hungarian journal, **Egység** (Unity no 4, Berlin), warning against bourgeois tendencies in Russian

Constructivism, and aestheticism in De Stijl, and called for a new Communist culture comprising a proletarian, collective art of a high standard

Spring. Joined the faculty of the Bauhaus, Weimar, as head of the Preliminary Course (aided by Albers), and the Metal Workshop. The Bauhaus aimed to inject a new, creative, corporate attitude into industrial, mass-produced design, united under Architecture, by welcoming the special assets of the machine age, but with emphasis on educating 'the whole man'

Moholy then extended the Preliminary Course by one term, and changed the policy of the Metal Workshop from individualistic work in expensive metals to practical problems in metals consistent with mass-production, such as electric household-appliances and lighting-fixtures. Some of these designs were taken up by industry and are still available, little changed. Because, from its inception, the Bauhaus had had outspoken critics of its work, methods, and intentions in conservative Weimar, Gropius had tried to keep it apolitical

July—September. Moholy exhibited at the Bauhaus Exhibition at which Gropius's theme, *Art and technology—a new unity,* was presented. This exhibition met the Weimar government's demands for the Bauhaus to prove itself by showing concrete achievements

1925 April; after an unacceptable level of political pressure in 1924, the Bauhaus moved to friendly Dessau, in Anhalt, into purpose-built accommodation designed by Gropius

Moholy had now become Gropius's 'Prime-minister', and, as such, was the most important member of the Bauhaus staff. He created antagonisms by outspokenly prophesying the victory of Photography over traditional Painting

Appearance of the Bauhaus Books, co-edited by Moholy together with Gropius, with much typographical design by Moholy, including his own *Painting, Photography, Film* first edition 1925, second edition 1927. Also contributed an essay to Schlemmer's *The theatre of the Bauhaus*

The Moholys carry out photographic experiments privately using their newly-acquired laboratory (the photograms had begun 1922, the photoplastics, 1923)

1926 Moholy's first film documentary, *Berliner Stilleben* (Berlin Still-life)

1928 January 17, Moholy resigned position from Bauhaus, and left in Spring, following a new Communist demand from a sector of the staff and students for vocational training at the expense of the broad education of the original programme. Gropius, Breuer and Bayer also resigned.

Spring 1928—May 1935. Commercial design office in Berlin. From 1930, in association with Gyorgy Kepes who became his assistant.

Worked for, among others, Schott and Gen.Jenaerglas, and for the *Konfektionär* magazine.

1929 May 18—July 7. Participated in *Film und Foto,* Werkbund exhibition, Stüttgart

Autumn. Talked at the Institute of Sciences, Bielefeld, about the Bauhaus

His last Bauhaus Book, *The new vision* (Von Material zu Architectur), appeared

1929—1931. Stage designs for the new Kroll Opera, an independent branch of the State Opera in Berlin, under Otto Klemperer, until its closure by the Nazis in July, 1931. Worked on *Tales of Hoffmann* 1929; also *Hin und Zurück,* by Hindemith 1930; and *Madame Butterfly* 1931. Also designed for Erwin Piscator's political theatre in Berlin: *The merchant of Berlin* by Walter Mehring, written 1929; banned after the first performance at Piscator Theatre in 1930

1930 Spring. Met his close, English friend, J G Crowther (Science correspondent of *The Manchester Guardian*) in Berlin

May 14—July 13. Moholy participated in the Werkbund section of La Société des Artistes Décorateurs exhibition in Paris, staging an exhibition of Bauhaus work, and also his *Light prop*

Made his film, *Light play, black and white, and grey* from the *Light prop*

Moholy-Nagy

Summer. Began work on the **Room of our time,** Landesmuseum, Hanover, in association with the director, Alexander Dorner

1930—1931. Brief teaching visits to the 'Budapest Bauhaus' (Mühely), run by one of his early **MA** associates, Sandor Bortnyik

1931 Winter. Met Sibylle Pietsch, a scenario writer for the Tobis Film Company and former theatre actress, whom he later married

October. First exhibition in America (photographs), at Delphic Studios, New York

1932 Joined the Abstraction-Création movement in Paris. As a result, he met Ben Nicholson and established his earliest contact with English Art

1933 March 5 Hitler's general election success

July 29—August 13. Attended CIAM (Congrès Internationaux d'Architecture Moderne) cruise between Marseille and Athens, when he met the architectural writer, P Morton Shand, who tried to attract him to England, and became a close friend

Made the official film of the Congress

November. First visit to London

December, 1933—May 1935. Lodged in Holland where, as Art director, he created the image of the new Amsterdam periodical **International Textiles**

By Christmas, he was in contact with Herbert Read in London

1934 August. In London, learning the colour-copy-process at Kodak. August 16. Moholy was ordered to submit three pictures to the Jury of the Nazi Reichskulturkammer (Chamber of Culture) to decide whether he should be allowed to join the Reich Syndicate of Fine Artists. In the event, there was a postponement until October 23, but the outcome is not on record. By this time, Hitler's powers were absolute

October 18th. Walter and Ise Gropius arrived in London as guests of Jack Pritchard at 15, Lawn Road Flats, Hampstead. Subsequently, he became consultant and designer, with Breuer (who arrived June 27, 1935) for Pritchard's Isokon Furniture Company. Moholy was to design advertising material for Isokon

November 24—December 9. Moholy's one-man show organised by the Dutch Society for Arts and Crafts (VANK) at the Stedelijk Museum, Amsterdam

1935 March. Designed **Utrecht Jaarbeurs** (Spring Fair) for the International Bureau for the Sale of Artificial Silk

April 27—November. Stand for International Bureau for the Sale of Artificial Silk at the Brussels International Exhibition

May 19 or 20. Moholy arrived in London. After about three months at Lawn Road Flats, he rented 7 Farm Walk, Golders Green

Before September. Had begun work on the film, **Lobsters,** completed June 1936, and met John Grierson at the GPO Film Unit

Discussed the possibility of an English Bauhaus

December 6—February 2 or 3 1936. **The Empire's Airway Exhibition** (Science Museum, South Kensington) for Imperial Airways. This was followed by shows on the same theme at Charing Cross Underground Station, June 18—July 7 1936, and in their Exhibition train, July 12—December 3 1937

1936 February 21 The Korda film, **Things to come,** premiered at Leicester Square Theatre, London, containing short extracts from Moholy's special-effects sequence

April 4—30. Exhibition of Moholy's prints at the Royal Photographic Society, 35 Russell Square, London

April 29. Formal opening of Simpson (Piccadilly) Ltd, Moholy design consultant until he left for America

May 1—June 20. Among exhibitors at a contemporary Art show held at Leicester Museum and Art Gallery

László Moholy-Nagy, Brighton, England 1936
photograph by Serge Chermayeff

August. Attended Olympic Games in Berlin to fulfil photographic and film commission, but abandoned the project, and travelled on to holiday with his wife in Hungary

About October. Publication of the book **The streetmarkets of London,** by Mary Benedetta, with photographs by Moholy

December 31 1936—January 27 1937. One-man show at The London Gallery, Cork Street, London

1937 February. Moholy's specially-commissioned film, **The new architecture at the London Zoo** included in the exhibition, **Modern architecture in England,** at the Museum of Modern Art, New York

Advertising posters for London Transport

March 12. Gropius left to take up his Chair in Architecture at Harvard and made strenuous efforts to gather his major collaborators in America. An outcome was Moholy's appointment as head of the New Bauhaus in Chicago, backed by the Association of Arts and Industries

July 1. Sailed for America

Late August. Holidayed with Gropiuses, Breuer, Bayer, and Schawinsky of the former Bauhaus. They planned their future strategy, including a Bauhaus exhibition arranged for 1938 at the Museum of Modern Art

October 18. Opened the New Bauhaus, Chicago

November. Publication of **Eton portrait** by Bernard Fergusson, with photographs by Moholy

July—November. Works by Moholy were removed by the Nazis from public galleries in Essen, Hanover, and Mannheim, in their drive against 'degenerate art'

1938 Summer. The New Bauhaus forced to close because of bankruptcy of the backers

December. Publication of **An Oxford University chest,** by John Betjeman, with most of the photographs by Moholy

1939 February. Using his earnings from commercial design, he opened his School of Design, Chicago, and from 1940, conducted a summer school at a farm at Somonauk, Illinois, leased by a major financial backer,

Walter Paepcke, President of the Container Corporation of America

1942 January. At a period of financial crisis provoked by the War, he had the School designated as a certified school for camouflage personnel, catered for returning wounded servicemen by occupational therapy classes, and sought substitutes for materials made scarce by wartime

1943 1943 until his death, worked on what he called his visual testament', the book, **Vision in motion** published 1947

1944 Spring. The School changed name to The Institute of Design, Chicago, to stress its college status. Now backed by Chicago businessmen. Despite major problems, Moholy's Institute was very successful at his death

1945 November. Leukaemia diagnosed

December. Text of **Vision in Motion** complete, and Moholy was now 'pondering' about illustration captions

1946 February 14. In a letter, Moholy stated categorically that 'as an artist I never had any political affiliations'

July 31. About the time of his sudden deterioration in health, Moholy sent Paepcke his suggestions for a successor: Breuer, Jose Louis Sert (town-planner), Gyorgy Kepes (of MIT), Knul Leenberg Holm (architect), and the American designers, Ralph Rapson, and Charles Eames. Moholy stressed that educational aptitude and artistic qualities were of equal importance to prevent the Institute becoming 'just another engineering school'. During Moholy's illness, the French painters, Amédée Ozenfant and Jean Hélion, were each asked to take over direction of the Institute, but declined. In the event, the architect, Serge Chermayeff, succeeded Moholy

November 24th Moholy died At his death, among other offices he held was Director of the American Designers' Institute.

Moholy-Nagy's works

by Terence Senter

The direction initiated by **Épits** 1919 continued in the Dadaist constructions of 1920, and closely related paintings eg **Composition** c.1921, dedicated to his Berlin Dadaist friend, Hannah Höch, University of East Anglia, and the highly abstracted themes based on the Berlin railway and tramway eg **Construction** 1920, 17, 142; and **Large railway picture** c.1920, private collection, Vienna. Distinctive configurations, reflecting the axes of the frame, are provided by stylised cogs, gears, pulleys, bridges, water, signals, barriers, scaffolding, and tracks, sometimes accompanied by purely geometrical shapes, and letters or numbers chosen only for their formal appearance. **The great wheel** (Die grosse Gefühlsmaschine) c.1920, Stedelijk van Abbemuseum, Eindhoven, predicted Moholy's subsequent, non-figurative works in the dominating circle, the divided, small circle, the tip-to-tip, distorted rectangles, implying tilting into the pictorial space, and the thin strip extending from a wider one. This strip formation draws attention to his varied play with one element, and may be understood as one strip superimposed on another (as unequivocally in **Construction 'p'** 1920, 8, 52), or as a mirrored duplication of two abutted strips such as those seen in his contemporary **Sculptural assemblage in machine worked wood** 1921, lost, and **Architecture III** c.1920, Städtisches Museum, Wiesbaden, or its slight variant, on the cover of MA (May 1st, 1922), which also incorporates his interest in transparency. The formal repetition and varied directions in **The great wheel**, including the strip in front of, and at different depths behind, the great, outlined circle, indicate his early interest in kinetics. His film script, **Dynamic of the metropolis** 1921—1922, reconciled the various parts of his outlook controlled by the time-element with an emphasis on movement and pace. **Composition** (1921, Busch-Reisinger Museum, Harvard) is a relatively loose arrangement of elements reminiscent of **Still-Life** (Der Radfahrer), and the sweeping arrangements of black, positive, and white, negative areas in Sandor Bortnyik's earlier, highly abstracted linocut (published MA, June 15th 1919), Moholy's Composition hints at his future transparency pictures by playing on overlapping effects such as those at the number '12', and the inverted bottle in the upper, right

corner, where the tones become reversed.

Moholy's geometric abstraction developed against a background of new, German enthusiasm for experiment with glass architecture, based on the Expressionist poet, Paul Scheerbart, and his conceptions of the world's transformation by exploitation of glass which, with a wider use of electricity, would colourfully illuminate the night. In 1919, when Gropius had headed the radical Arbeitsrat für Kunst (Work Council for Art), he and fellow-member, Bruno Taut, even chose crystal to symbolise humanity, the new spiritual idea and universal brotherhood. Expressionistically, in his opening Bauhaus declaration of 1919, Gropius had called for craftsmen and artists to unite, to conceive and create 'the new building of the future which will rise one day toward heaven from the hands of a million workers, like the crystal symbol of a new faith', and Feininger provided the image of a medieval cathedral, which for Gropius, epitomised the fusion of balanced, co-operative effort.

Moholy had encountered his theme of transparency whilst trying to sketch a 'type of 'glass architecture'', which he had planned in the form of glass and metal assemblages, prompted by his observation that the natural colours of materials in his Dadaist constructions reacted more potently than painted surfaces to direct lighting. All of his constructions from this time are lost, but surviving photographs indicate that **Two constructive systems combined** 1921—1922 (steel, copper, nickel, aluminium, zinc and crystal) represented a critical stage that paralleled his procedure with Still-life (Der Radfahrer) by associating two, already complete and independent compositions, to achieve a new unity. He spoke of the dematerialised 'floating' effect produced here by the highly reflective, industrial materials, 6, 126, a feature that was to be developed. Now, only simple, geometric forms were employed.

In Painting, Moholy's desire for undisturbed clarity, and '**liberation from the necessity to record**', led him to choose what he called '**simple**', '**neutral**', '**geometrical forms as a step towards . . . objectivity**' 14, 75. **Construction** (1921, whereabouts unknown, 26, 183) shows the early, limited range of superimposed, contrasting rectangles that emerged from his imagining himself painting coloured lights projected over one another onto a screen. He discussed later how he enhanced this effect, by imagining instead, translucent screens of different shapes, each bathed in a coloured light, and placed one behind the other. His drive towards '**objective validity**' then led him to regard the work as a machine product, and to suvpress the personal touch even by using colour sprays. He described his '**desire . . . to work with the peculiar characteristics of colours, with their pure relationships**' 14, 75. Dispassionate, industrial processes provided the objective yardstick when he separated the creative idea from its execution by ordering one composition in three sizes from a sign factory, using their porcelain-enamel color-chart, and plotting the layout of his shapes on graph-paper. With the results, he felt that he could more accurately gauge the apparent disturbance to a fixed colour relationship brought by changing dimensions (Em I ■ II ● and III ▲ 1922—1923; porcelain enamel on steel; Museum of Modern Art, New York). Later, in his commercial career, this belief in the legitimate division of conception from execu-

The American material finish *porcelain-enamel* is known in England as *vitreous enamel*.

■●▲
The three enamels, Em 1/2/3, are of the same design but were reproduced in different sizes according to Moholy's instructions. They are represented here reduced, but in proportion to one another.

Moholy-Nagy

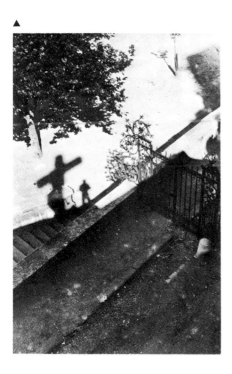

tion provided his grounds for employing an assistant to realise his ideas. Moholy established a repertoire of titles evocative of machine serial numbers □.

Moholy regarded his transparent paintings as '**static phases of ... light displays**', *14, 84,* the first stage towards painting with light itself, and explained his device of repeating the main motif on a smaller scale, or in a distorted form, within the same picture-space as stressing the kinetic nature. This device was to be greatly enriched by reflected distortions of motifs from the surfaces of plastic sheets or shadows thrown behind them. What he called the free 'motion' of colour backwards and forwards, in opposition to Renaissance illusionism of the third dimension, applies not only to his late work, but to that of the 1920s. This, he felt, related him to others seeking to define intuitively, and to satisfy adequately '**the specific need of our time for a vision in motion**' *14, 86. K VII* 1922, Composition *A 18* 1927, and *A 19* 1927 admirably illustrate these points. In K VII ■ the large motif of upright black rectangle, grey square, dividing horizontal black strip and upright dividing red line, with appropriate transparencies, is repeated, more faintly, and on a smaller scale in the upper right part of the painting to produce what he termed '**a new dynamic form of harmonious organisation**' comparable with classical composition *14, 84.* The regular forms appear stable since they echo the axes of the frame, a factor which, allied to the grid-like divisions, recalls Mondrian (see, too, **LIS,** *c.1922*). But the questions might be asked 'Which elements are transparent, and what is their order in depth? Their vagueness, and our successive reinterpretations of their layout to solve their relative positions, produce that free 'motion' claimed by Moholy. The ambiguity is further aggravated by Moholy's calculated departure from consistency at vital points. In A 19, an apparently unsynchronised superimposition of a cross-motif strongly suggests two stages in a circular movement, whilst in another related work **A XXI** *(1925* Münster), there is also a transparent strip which has been given the power to magnify the part of a striped bar that it crosses, a mixture of spatial fields paralled by photoplastics eg **Leda and the swan** *1925.* Composition A 18 demonstrates further the fresh possibilities in repetition and measured distortion, this time, of the rectangular strips which are difficult to see as flat though they use no perspective illusion. Moholy has calculated their T-plan relationship to suggest two distinctive, spatial orientations at the circumference of the circle. He maintained that the placing of motifs was intuitive. A 18 employs his discovery that, by connecting points which seemed to correspond, a mathematical balance, a 'spatial network', and an 'unusual diagram of tensions' resulted, which, he felt, symbolised motion, and was to be developed, in his later, plastic paintings *14, 84.*

His basic configurations are easily enumerated, but there is a multiplicity of fresh, intuitive interpretations and permutations. **Construction** *1923—1925* (Stuttgart) recalls his photograms in that the circles and grid are negative impressions, masked from the airbrush. The reversal of positive and negative, subject and background, reappears in another guise in his self portrait as a cast shadow on the landscape **(Moholy photographing his own shadow,** *1926* or *1928* ▲). Moholy's favoured circle-and-strip relationship is still central in the Stuttgart Construction, but the main elements have their

□
However, Sibyl Moholy-Nagy has commented that the expected strict system actually broke down in about 1925. Until then, she explained, the **A** prefix had separated oil-paintings on canvas from those on other supports, but subsequently, **Z**s and **R**s began to appear out of sequence, apparently prompted by secret, personal associations. Other abbreviations refer to materials, or cities (**Al** = Aluminium; **Gal** = Galalith plastic; **Cel** = Celluloid plastic; **Rho** = Rhodoid plastic; **Sil** = Silverit, a form of aluminium; **Em** = Email [German for 'enamel']; **Q** = loss of numerical sequence; **L** = London: **CH** = Chicago; see *31,77; 33,17;* and *43,17*).

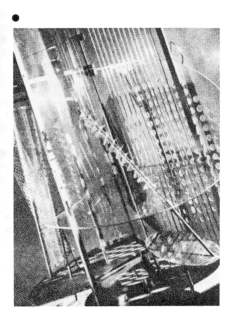

own space, the white paper located within the area of brown. In other compositions, an inner picture space can be turned slightly eg *O.P.4, c.1924,* Annely Juda, *1971,* or a single picture space can be fractured and its contents along with it *(Divided collage; c.1923;* L.M.N. Chicago, Art Institute, 1947, no 54). Many of these devices were adapted for his commercial graphics, especially evident in the periodical, *International Textiles* (Amsterdam), between 1933 and 1936, and his photography, film, and theatre design.

In 1928, a Bauhaus student wrote that Moholy often used the words **'tensions'** and **'inhibitions'** during conversation in his reasoning about painting *42,156*. Some idea of what he meant emerges from his article on contemporary typography, 1926, where he described **'tensions'** in **'contrasting visual effects'** as **'created by opposites: empty-full, light-dark, polychrome-monochrome, vertical-horizontal, upright-oblique,'** etc *42,81* and, elsewhere, added **'centric-eccentric, centrifugal-centripetal, warm-cold, advancing-receding, and light-heavy colour arrangements'** *4,13*.

His richly varied use of the circle provides a typical instance of his agile invention: **a** the understood intersection in **Coloured segments** *1922—1923* Indianapolis Museum of Art, in which spaces between similar, close arcs have become the subject, a procedure repeated in photoplastics, for instance **Murder on the rails** *1925*; **b** his experimental, concave, circular cinema-screen for showing simultaneously two or more films roving over its surface until within a planned period, they coincide, and their independent themes become fused; **c** the use of the emphatic circle to enliven otherwise humdrum commercial layouts; **d** the containing shape of the plans for the **Lichtrequisit** *1930* ● **e** the glass globe bearing the opening caption in his film, **Light play: black and white and grey** *1930*; and **f** his symbol for the atom appearing to split itself apart geometrically, by contrasting radii, rather than by impressionistic means, in **Explosion of a bubble** *1946*.

The circle was for Malevich a 'basic suprematist element', the first suprematist form to develop out of the square in 1913 *29,70*. Moholy recalled how, in 1922, Lissitzky, Ehrenburg and Gabo brought news to Berlin of Malevich, Rodchenko, and Suprematism *14,80*. On one occasion, Lissitzky, along with other regular visitors to Moholy's studio, Hausmann, Höch, Richter, and Gräff discussed there the new 'Sachlichkeit, objectivity in general, expediency, (and) the principles of the Weimar Bauhaus', and Lissitzky held forth about the demands of the Revolution on Russian artists and architects *28,34*. Moholy's abstraction, like Lissitzky's, played on the inherent capacity of certain simple shapes to suggest the third dimension, but in, for instance, his paintings that interchange subject and background, he departed radically from Lissitzky's 'prouns', with their suggestion of resolved isometric views of free architectural assemblages. Generally, Moholy was closer to Malevich's views of 'action' on the flat picture field of the realistic, geometric forms produced by 'utilitarian reason' of 'the movement of colour as energy', of the artist's obligation to produce ever new forms, the equation of universal art and revolution, and of a quest for the infinite. However, Malevich's ultimate reductionism to symbolic signs (in form and colour dictated by the principle of economy) that signify an

Moholy-Nagy

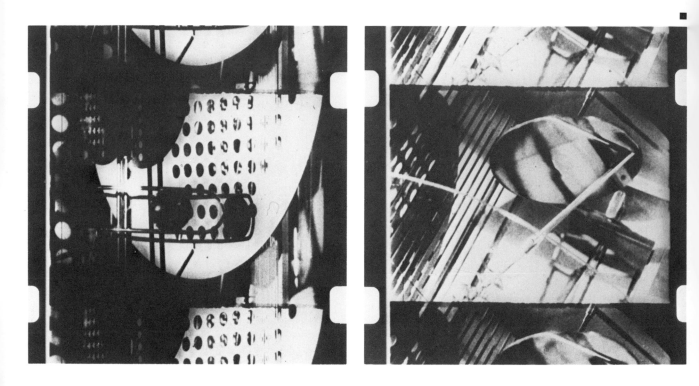

extremely cerebral, cosmic world beyond the 'animal' sphere was anathema to Moholy's biological, sense-based outlook that allowed him to refer to paintings as **'organisms'** *2,60*. Moholy employed the highly differentiated, saturated colours demanded by Malevich, but, at the same time, his transparency effects provided a subtle range of mixed variations. In 1925, he regarded **'the task of painting, seen as colour creation, to organise clearly primary (apperceptive) colour effect'**, in which the eyes' alleged automatic response to specific colours by the mental production of others, was the phenomenon to be investigated rather than the use of 'associative' colour based on preconception *2,57*. Just as his interest in Suprematism stopped short at its fresh, visual possibilities for his own world scheme, so, too, did his response to the diagonal, cellular structure of Van Doesburg's Elementarist creed, reflected in **A XI** *1923—1924*.

In 1937, Moholy declared that as light was an element of the space-time continuum, to re-examine light was also to experience a new feeling for space, impossible yet to analyse, although **'it is a thing which can be summed up in a word—floating'** *23,174*. His paintings on plastic sheets of the early 1920s represented his early steps towards working directly in light, but he found that pigment, as usual with 'technologies', became a detour in his effort to tap his light-vision at the mind's source *3, unpaged*. Similarly, his photoplastics present another aspect of his desire to follow the mind's processes of registering experiences by simultaneously recording a series of continuous events, or random selections from complex, instantaneous happenings. His documentary photographs from unusual angles were intended to speak directly to the mind, emphasising the myriad, visual distortions that conventionalised sight overlooks. In this context, Rodchenko was accused by **Sowjetskoje Foto** (no4/25;1928) of plagiarising Moholy which had illustrated its point by making comparisons. Rodchenko's defence referred to the 'first-rate work of so exceptional an artist as Moholy-Nagy, whom I regard very highly', and continued that this 'formerly leftist non-objective painter', who had written of his debt to Rodchenko's paintings, had repeatedly requested photographs from him *40,52*. Moholy contended that the photographic medium could productively revolutionise our visual range by, for instance, micro-, macro-, and X-ray photography. He regarded his photograms as fundamental photography since they recorded the directly controlled action of light on a chemically-sensitive surface. From their inception in 1922, he used various fluids, and transparent and translucent solids as subjects. Finding that the effects usually showed themselves in motion, he concluded that **'the process reaches its highest development in the film'** *27,117—118*, a point that he extended in the last year of his life by pronouncing that **'motion pictures, more than anything else, fulfil requirements of a space-time visual art'** *15, unpaged*. He regarded the photographic series as pointing towards fulfilment in a fully kinetic film medium. In sound film, his productive goal was the direct manufacture of new sound experience by hand-drawn sound-tracks. He stated that **'this "synthetic" music is the acoustic conterpart of the photogram'** *13,24*. Ironically, his most developed attempt to fuse light and sound by film, the **ABC in sound** (*1932;* 3 minutes) has been lost, but reports of it indicate that adjacent picture frame and track carried similar images, including typography, profiles, and fingerprints. Thus, after interpretation by the photo-electric cell, the images would have permitted the audience to hear them.

His early concern with kinetics had a social outlet in his **Kinetic constructive system** *1922*, a recreational spiral structure (for Moholy a decisive space-time symbol since both inside and outside could be seen simultaneously) up which the public could walk before facing a variety of means of descent. The conception was refined in 1928 when Moholy collaborated with Stefan Sebök, an engineer employed by Gropius, who also worked on the **Light prop** (Lichtrequisit *1922—1930*) at the same time. The Light prop was a summary and climax of Moholy's experiments of the 1920s. He planned this machine as an attempt **'to synthesise simple elements by a constant superimposition of their movements'** *14,80*. It was constructed from metals, plastic, and wood, with a variety of shiny and matt surfaces, and had a circular plan, divided into three equal sectors, which carried different mechanical actions (waving metal flags, revolving glass spiral, and elevating disc), the whole assembly rotating once every forty seconds, whilst a two minute programme of 116 coloured lights in the three primaries, red, blue, and green, plus yellow and white, played directly on its surfaces, and could be projected. Blue was the control colour throughout, making twenty-one appearances out of a possible twentyfour, but mixed in a variety of ways, with no simple repeating pattern. As the Light prop was never shown after 1931 with its coloured illumination programme, it lost its original identity, and the full significance of Moholy's ecstatic description of its **'transparencies in action'**, its **'interpenetration in fluid change'** **'its shadow sequences'**, could only be imagined. He recalled that he had learnt **'much from this mobile for my later painting, photography, and motion pictures, as well as for architecture and industrial design'** *14,80*. He used the machine as the basis for his film, Light play: black and white and grey *1930* ∎ uniting it with his radical views of the distinctive properties of the film medium (dominant modulated movement, superimpositions, repeats, negative printing and closeups, outdoing any natural viewpoint), rather than producing a documentary record.

Moholy-Nagy

List of works
paintings, sculptures, watercolours, drawings

Works are from the collection of **Hattula Moholy-Nagy** unless otherwise stated. Dimensions are given in centimetres, height before width. The notes were written by Terence Senter.

Painting, sculptures

1
Hungarian Fields
1919
oil on canvas
65×75
private collection, Austria

2
Landscape with houses
1919
oil on cardboard
61×87
Galerie Klihm, Munich

3
Black quarter circle with red stripes
1921
oil on canvas
93×74
private collection

4
K VII
1922
oil on canvas
115×136
Trustees of the Tate Gallery

5
Z III
1922
oil on canvas
96×75.5
Galerie Gmurzynska, Cologne

3

He has recalled: '**I became interested in painting with light, not on the surface of canvas, but directly in space. Painting transparencies was the start. I painted as if coloured light was projected on a screen, and other coloured lights superimposed over it**' *14,75.*

3

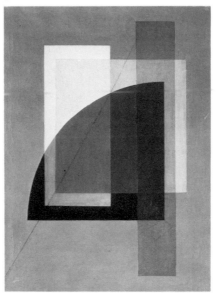

4

K VII was intended to express overtly his concern with kinetics, shown elsewhere in his film-script, ***Dynamic of the metropolis*** *1921—1922,* and his contemporary, recreational ***Kinetic-constructive system*** *1922.* He often regarded his early, '**transparent' paintings as 'static phases of ... light displays',** and, to increase the kinetic sense, repeated the main motif on a smaller scale, or in distorted form, within the same picture area. Using repetition brought '**a new dynamic form of harmonious organisation'**, comparable, for Moholy, with the symmetry and golden section of classical fore-runners. He concluded: '**I seemed to achieve a more delicate and sensitive solution of harmony and relationships by my attempts at repetition of the elements, and by changing the sizes of the units** *14,84.*

The title is an instance of his desire for objectivity. Now, he regarded his works as industrial objects, gave them serial-numbers for titles, and confined all information, including his name, to the reverse side. An extreme test of such thinking was his submission of an order to a sign-factory for paintings to be industrially produced to his own specifications (***Em I, II, III,*** 1922) *14,79.*

6

LIS
1922
oil on canvas
135x114
Galerie Klihm, Munich

7

C XVI
1923
oil on canvas
101x80.5
private collection

8

A XI
1923-24
oil on canvas
135x117

9
A 19
1927
oil on canvas
60x96

10

Sil 1
1933
oil on Silberit (a form of highly
polished aluminium)
50.2x20
Scottish National Gallery of Modern Art,
Edinburgh

6

Looking back in 1944 to the singularity of his interests, he was to realise with surprise that: **'since I began my abstract paintings, I did not paint any shape which was not the interpretation of the original departure, the strip, used in my first collages. By slight distortion, although I had not been conscious of it, I continuously changed this shape on each occasion believing that I was inventing something new'** *14,86.*

7

Moholy's interest in distortion as a symbol for action seems to derive from 1922. *C XVI* represents the emergence of one of his most favoured forms, the strip, minimally distorted by maintaining parallel, opposite sides. Moholy also used such laterally inverted strips in a linocut design for the cover of the montly art magazine **Der Sturm** *January 1923*, and intersected one pair to carry the title in his project for a cover-design for the arts periodical, **Broom** *1923.*

8

Oblique layout and cellular structure were to underlie many of Moholy's subsequent photographs, for instance, **Hotel terrace, Ascona** *1928* colour, and **Rue de Cannebière, Marseille** *1929* Larson Collection, to which Moholy added an illuminating explanation which could also be applied to the paintings: **'A street is seen through a balcony railing. The unfocused railing separates the scene into individual cells through which their spatial quality is more emphasised. These divisions appear also as if they were parts of a broken mirror, where the broken parts are lying on different levels'** *27,65.*

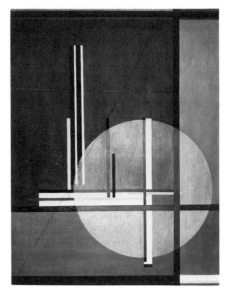

10

Moholy's formal vocabulary is used in conjunction with another of his pioneering fundamentals of the 1920's, the use of **'the new materials'** as painting supports. In 1927, he explained: **'Valuable artificial materials are being produced today for the electrotechnical industry: turbonite, trolite, neolith, galalith, etc, etc. These materials, like aluminium, cellon, celluloid, are much more suitable for pictures which have to be accurately executed than are canvas and wood-panel. I do not doubt that these or similar materials will soon become the ones most often used for easel paintings and that it will be possible to achieve quite new and surprising effects from them. Experiments with painting on highly polished black panels (trolite), on coloured transparent or translucent plates (galalith, matt and translucent cellon), produce strange optical effects: it looks as though the colour were *floating* almost without material effect in a space in front of the plane to which it is in fact applied'** *4,25.*

Moholy-Nagy

Light prop

11

a Light prop for an electrical stage
(Lichtrequisit)
1922-1930 (Replica 1970)
Mobile construction in various metals,
plastic and wood
151×70×70
Stedelijk van Abbemuseum, Eindhoven
11a see also insert at pps 40, 41

b Catalogue
Exposition des artistes décorateurs.
Section Allemande (Werkbund) Paris,
Grand Palais, May 14th—July 13th, 1930
Catalogue, designed by Herbert Bayer
21×15
Harry Blacker

This exhibition made possible the realisation
of Moholy's *Light prop* (Lichtrequisit) when
AEG backed its construction for inclusion in
the German section

Moholy's definitive pioneering work in kinetic light art, intended to stand alone on stage, partly boxed in, so that the audience could see through a porthole its direct response to a two-minute illumination sequence provided by 116 coloured bulbs, as well as the simultaneous projection of its light play, through the apparatus, onto a screen behind it.

Moholy spoke at some length about this work, stating its purpose as **'an experimental apparatus for "painting with light"', and 'a space kaleidoscope'** … **'to synthesize simple elements by a constant superimposition of their movements.'** He had designed the mobile **'mainly to see transparencies in action,'** and was surprised to see shadows on transparent and perforated screens, **'new visual effects, a kind of interpenetration in fluid change'**, as well as unexpected mirrorings making opaque metals appear transparent. He dated the conception of the work back to 1922, but the machine was not produced until 1930, after he had met Stefan Sebök, a young Hungarian engineer, connected with Gropius's office, and had the factory facilities (theatre section) and financial backing of AEG, Berlin. **The Light prop** became the abstract subject of his film, **Light-play: black and white and grey,** made in 1930, not as a documentary, but as an exploration of the way the special properties of the film medium could extend his visions of interacting space, time, and light, conveyed by impersonal (objective), mechanical forms. Despite his feeling that he had 'almost believed in magic', when he saw the working machine, he could find no backers to continue, and, as he explained to his friend, Kalivoda, in 1934, **'it took a great deal of work to assemble all this material, and yet it was only a modest beginning, an almost negligible step forward'.** Yet, ten years later, he recalled that **'I learned much from this mobile for my later painting, photography, and motion pictures, as well as for architecture and industrial design'.**

This appears to be the first reconstruction of Moholy's original realisation of 1930, incorporating his published illumination programme, employing the physical primaries, plus white (theoretically, fusion of all primaries), and yellow (another yellow being made by the fusion of red and green).

The apparatus is divided into three sectors, or cells: a set of metal flags, a glass spiral, and the metal discs. Sebök's technical plans indicate that a different order was originally intended, with the flags followed by the discs, and Moholy discussed those features in that order in 1930. The main clockwise revolution of the present machine concurs with the plan in Cologne, but contradicts that in the Bauhaus Archiv, Berlin, reflecting the fact that, even after he had completely visualised all sectors, Moholy could consider the stage of actual combination as a separate act in the tradition of his explanation for **Two constructive systems combined** (*1921—1922; lost*) and his photomontages.

His published text-references to the number of light bulbs are inconsistent: in 1930, he spoke of 'about 70 illumination bulbs, each 15 watt power and 5 searchlight bulbs, each 100 watt' on the outer plane, and 'also electric bulbs of various colours' on the inner plane. In 1946, he specified '140 light bulbs' and 'various coloured and colourless spotlights,' and, in the same source,' '128 electric bulbs in

11

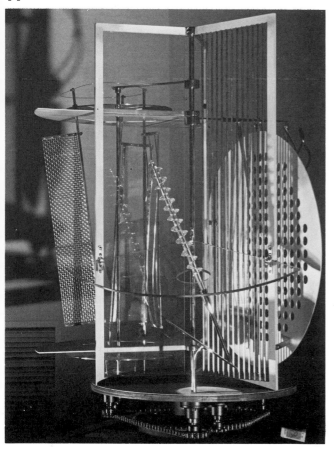

different colours'. All of these specifications differ from the actual, detailed programme which he illustrated in the 1930 source, and which includes precisely 116 bulbs (36 blue, 25 green, 20 red, 21 yellow, and 14 white), with no reference to spotlights. This programme and the measurements in Sebök's plans form the basis for the present reconstruction. Sibyl Moholy-Nagy claimed that Moholy asked her to write music for a future light-play film (although she had never written a note before in her life), when he showed her the *Light prop* in Berlin in Winter, 1931. The *Light prop* sums up his various interests of the 1920's, and he was to use the *Light play* film as a convenient sampler of his ideas.

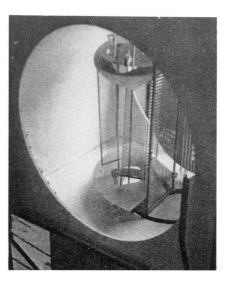

Moholy-Nagy

The light prop

The light prop was intended to operate on a theatre stage during an interval: hence its title. The machine has three sets of moving parts, geared at different speeds, which rotate in forty second sequences, the whole movement taking two minutes. Each set of parts is intended to modulate light projected on to it, reflect and cast shadow patterns across the stage.

(For this exhibition a reconstruction of an original colour light-programme, using 116 lamps, has been made.)

Moholy-Nagy

12
LK III
1936
oil on canvas
84x97
Galerie Klihm, Munich

13
L + CH
1936—1939
oil on canvas
97x76
National Museum of Wales, Cardiff

14
CH 4
1938
oil on canvas
70x90.5

15
Two-tone
1945
oil on Plexiglas plastic, mounted at an
angle to a wooden background
61x46

Watercolours, drawings

16
Landscape with barbed wire
c 1917
black crayon on paper
47.5x61

17
Self Portrait
c 1919
pencil on paper
37x30

18
Der Radfahrer
1920
collage on paper
59.5x46.5
Kunstmuseum, Dusseldorf, Graphische
Sammlung

13
The cryptic, abbreviated title signifies that
this painting was begun in London and com-
pleted in Chicago.

14
Moholy's liking for tubular furniture struc-
tures, which he had hoped to try out in **'other
structural and architectural experiments'**
14,86, found an outlet in his American wire
and moulded plastic **'space modulators'**.
These, he described as **'related to the spa-
tial quality of endlessly bent tubular furni-
ture'**, and referred to his attempts to achieve
similar effects on canvas. **CH 4** is one
example.

16
Drawings, including *Landscape with
barbed wire* and *Self-portrait c. 1919,* were
among those that, in 1944, he described as
creating **'a complicated network of a
peculiar spatial quality ... showing not so
much objects as my excitement about
them'** *14,68*.

16

12

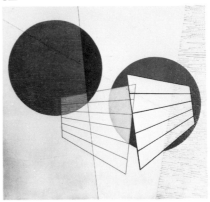

15
When Moholy contributed examples of his
new painting on Rhodoid plastic sheets to a
group exhibition at Leicester Museum and
Art Gallery in May-June, 1936, the organ-
iser, Charles Sewter, found that he had not
yet decided on how they should be dis-
played. Thus, Sewter hit on the idea of pro-
jecting the sheets about two inches from a
back-board by means of metal peg clasps.
Moholy continued this procedure in
America before changing to wooden chan-
nels. In this way, he developed works that
have come to be immediately identifiable
with him, works that he called **'an expres-
sion of a previously unknown kind'**.

18
In his autobiography, *Abstract of an artist
1944,* Moholy singled out this work as rep-
resenting a turning-point in his develop-
ment:
**'One day I found that my sketch for an oil
painting did not carry out my intention.
There were too many shapes pressed into
a chaotic arrangement. I took scissors.
Cutting away some parts of the drawing,
and turning it at an angle of ninety degrees,
I was satisfied. When the remnants were
pasted on a new sheet, the whole had little
similarity to the still life which I had chosen
as a point of departure. People, accustom-
ed to naturalistic schemes, insisted that
this "still life", mutilated and turned upside**

19
f in feld
1920
collage and watercolour on paper
22×17.7
private collection

20
Composition
1921
collage and gouache on paper
32×23
Fischer Fine Art, London

21
Red collage
1921
collage
24×34

22
Composition
c 1921
collage and gouache
49.5×35
University of East Anglia, Art Collection

23
6 Kestnermappe (6 constructions)
Kestner-Gesellschaft, Hanover
Published Spring 1923 by Verlag
Ludwig Ey, Berlin in a limited edition of 50,
of which this is number 17
six lithographs, each 60.3×44.1
private collection

24
Constructivist composition
c 1923
watercolour on paper
25.4×31.5
Mrs Helen Serger, New York

25
Mechanical eccentric
1923
collage
60×40
Institut für Theaterwissenschaften der
Universität zu Köln

down, looked like a rider on a motorcycle. I
protested, but basically I had a feeling of
indescribable happiness, a feeling of the
complete autonomy of action. It occurred
to me that, if I could make such changes in
a drawing, I could also decide with the
same freedom the shapes and forms in
my oil paintings.' *14,71.*
He explained how, liberated, he went on to
change the colour schemes of his still-lifes,
and even to eliminate perspective from his
paintings, simplifying 'everything to geo-
metrical shapes, flat unbroken colours,
lemon yellow, vermillion, black, white
—polar contrasts.' *14,71.*

22
This represents the pictorial counterpart of
Moholy's lost, early reliefs, derived from his
paintings of 'the "industrial" landscape of
Berlin', built, he said, as 'new structures', and
his '**own version of machine technology,
reassembled from the dismantled parts'.**
He spoke of the influence of 'cubist collages,
Schwitters' "Merz" painting and Dadaism's
brazen courage'. *14,72.*

20

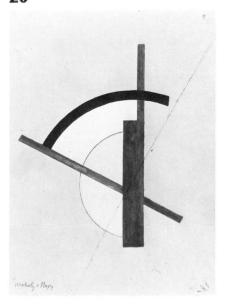

22

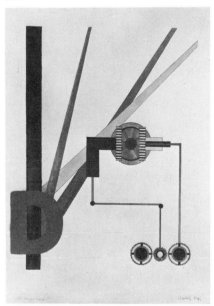

26
The construction scheme of the kinetic
constructive system
1928
collage and mixed media
70.5×48.5
Institut für Theaterwissenschaften der
Universität zu Köln

27
Light prop for an electrical stage
(Lichtrequisit) completed 1930
a Presentation of the motion-play in the first
sector in collaboration with Stefan Sebök
collage and drawing
60×40

b Display of the complete model 1930,
in collaboration with Stefan Sebök
collage and drawing
60×40
Institut für Theaterwissenschaften der
Universität zu Köln

28
Emery paper collage
1930
emery paper, cartridge paper, and
poster paint
21×28.6
Whitworth Art Gallery,
University of Manchester

29
Composition
1935
gouache on paper
19×30.8
private collection

30
Drawing
1942
crayon on paper
59×48.8
private collection

31
Explosion of a bubble
1946
crayon, chalk and pencil
28×21.5
Terence A Senter

32
Sketch related to hospital bed theme
1946
45.1×38.2
private collection

33
Untitled
1946
crayon, chalk and pencil
28×21.5
Galerie Klihm, Munich

33

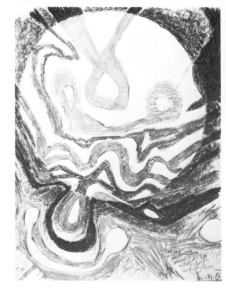

28

Photography

'Not those ignorant of writing, but of photography, will be the illiterate of the future'

Moholy-Nagy, 1928

During his extensive exploration of photography in the 1920's, Moholy documented his outlook in detail in two Bauhaus publications, **Painting, Photography, Film** 1925 and 1927, and his article, **Photography is construction with light** 1928, in the journal. His emphasis was on the thinking photographer, not the uncultured 'clicker', or 'shutter snapper', as he later called those 'without understanding of man'. He regarded **the characteristic 'optical focus' of the 1920's as 'the film; the electric sign, simultaneity of sensorily perceptible events.'** 4,39. Fully evolved, genuine photographic representation, he believed, would ridicule the feeble attempts at competition by imitative painters, but the very emergence of colour and sound films would oblige painters to direct themselves exclusively to 'pure colour relationships' or 'absolute painting' 4,13.

He began from the premise that photography had extended the eye's objective grasp of the world, its extremes of scale, visual subtlety, complexity of interrelationships, and peculiar distortions produced by the single viewpoint unprocessed by the mind. However, he dismissed the majority of everyday photographs as unproductive and sought a sound path of exploration from first principles to a fully productive form that would yield new relationships between the known and the emerging: in practice, a programme extending from the fundamental photogram to the photosculpture (Photoplastik). The essential issue was the response of the light-sensitive emulsion (silver-bromide) to the active force of light, so its conventional association with the camera could only deter any realisation of its immense resources by subjecting it to Renaissance perspective and denying it even the Cubist apprehension of the object from all sides, simultaneously, by systems of lenses and mirrors; likewise the possibilities of chemical compositions capable of recording electro-magnetic vibrations and x-rays invisible to the eye, and the development of **'cameras which are constructed on optical laws different from those of our eyes.'** 4,32. In retrospect, the holograph can be happily accommodated in such a conception.

Moholy-Nagy

Photograms

Moholy accepted that every material and field of activity, such as painting, had its own independent laws and mission, incapable of judgement from the standpoint of any other. Thus, in order to investigate the special properties and possibilities of photography, the photogram held the key, since the operator could directly manipulate the action of light on the photographic paper or plate. Although the camera could be used to record light compositions constructed from refracting or deflecting agents, Moholy **fixed what he described as the more fruitful, moving 'differentiated play of light and shadow' directly onto photographic paper without a camera.**

In the periodical, **Broom**, of March 1923, his earliest illustrated article on the subject spoke of his having made 'a few primitive attempts' which awaited further, experimental refinement when adequate facilities became available. Using lenses and mirrors, he had 'passed light through fluids like water, oil, acids, crystal, metal, glass, tissue, etc', casting the filtered, reflected, or refracted light onto a screen for photographing, or directly onto the sensitive plate without a camera. A composition which includes his abbreviated name 'Mo', and, as usual, echoes his painterly layouts (in this case, the cellular division of A XI, 1923—1924) was among the illustrations. When he and his first wife, Lucia, moved to the Weimar Bauhaus in Spring, 1923, they continued privately to produce photograms on daylight-paper which allowed them to watch the way the sun, or diffused daylight, was darkening the paper around the shielding forms of the solid, or translucent, objects. Only from 1926, after the Bauhaus moved to Dessau, did they have proper, technical facilities provided specially for Lucia's photographic record work, following her training in Weimar and Leipzig in 1923. Lucia has stressed that, for economy they used only paper-based emulsions ranging from 13x18cm to 18x24cm, so every one was a unique specimen, and only at Dessau did facilities permit the use of artificial-light, or 'Gaslight', papers (Kunstlichtpapier), on which, as Moholy noted, the progress of the generation of the picture could not be watched. The results were, in fact, negatives, and their potent whites balancing great planes of lustrous black by relative quantity, direction, and position, as well as the 'wonderful softness of inter-penetrating grey values' created 'a permeating light action' that excited him. Although positives could be obtained from these negatives, he indicated their 'harsher, frequently ashy grey values' 5, 4. For Moholy, the light-sensitive layer was a clean sheet on which notes could be made in light, just as the painter used brush and pigment on canvas, thus the possibilities of working with light became more fully opened up than by all earlier painting. In his last years (**Vision in motion** 1944–1946), he described the photogram as vision in motion, because, as a diagram of the motion of light, it created the space-time continuum. The photogram procedure suggested to him the means of producing the **'absolute filmic art'**, using, for example, adjustable slits or patterns through which the light intensity would be modified to vary the film-exposure continually, and thus provide a fluxing programme 4,44. He concluded that the master of cameraless photograms would be the most obviously able to work subsequently with the camera 5, 4.

34
Photographic triptych 1922
1922
photo-repro
28×35
Galerie Klihm, Munich

35
Laszlo and Lucia
1926
photo-repro
35×26.2
Victoria and Albert Museum

36
Photogram
1920s
photo-repro
39.7×30
Galerie Klihm, Munich

37
Photogram
1920s
photo-repro
35×26.2
Victoria and Albert Museum

38
Photogram
1933
original photograph
40×30
Sir John Summerson

35

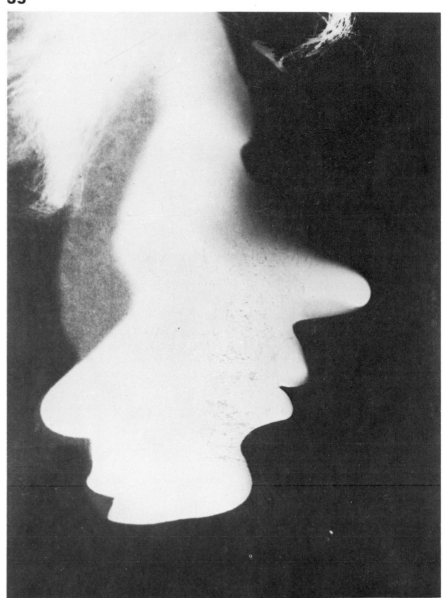

Camera photographs

39

Despite Moholy's recognition of the far-reaching possibilities in photography, his financial resources restricted him to **a** emphasis of the vast tonal range, expressed by positive-negative prints, **b** unusual viewpoints (bird's-eye, worm's-eye, oblique, and close-up), **c** attempts to side-step conventional, preconceived composition, by, instead, impartially confronting the action of light, **d** the sensory effects of surface treatment revealed by Cubism, and **e** a consideration of the length of photographic sensitivity in relation to the subject's continuous activity (space-time: superimposition, long exposures, multiple exposures). The forms from his paintings were to guide his photographic vocabulary.

He spoke of taking his first and only photograph before 1922 as an 'attempt at making two photographs superimposed as a portrait of a friend, Karl Koch.' *44.* Then followed his photograms, and, as he said, his serious consideration of photography in general. Moholy's photographic interests and experiments at the Bauhaus were privately conducted, and, though influential for some, were upsetting for others who disliked his talk of victory of photography over painting. Only a year after his departure was a photography department established there, headed by Walter Petehans, until Nazi closure of the Bauhaus.

By 1933, photography had become one of Moholy's major sources of income, and Lady Betjeman was among his sitters for portraits at that time. He admitted that, in Utrecht in 1934, his reputation as a photographer totally eclipsed his identity as a painter and a year earlier he had found that few of his contacts in England knew of his painting. His reputation as a photographer coloured the way that fellow-artists regarded him in England, but brought welcome commissions after his emigration from Hitler's Germany Through John Betjeman, he established an important contact with the short-lived London publisher, John Miles, an offshoot of the wholesale booksellers, Simpkin Marshall. The result was the series of books designed, photographically illustrated, and bearing dust jackets by Moholy: *The streetmarkets of London,* by Mary Benedetta *1936, Eton portrait,* by Bernard Ferguson *1937,* and *An Oxford University chest,* by John Betjeman *(published 1938, after his departure for America),* and the dust-jacket for *The face of the Home Counties,* by Harold Clunn *1936* (Simpkin Marshall). In his foreword to The streetmarkets of London, he referred to his approach as **'literary and impressionistic photo-reportage',** as the subject demanded, **rather than 'the purely aesthetic principle of pictorial composition'** which many readers might expect of him. As used, he explained, the pictorial sequence was **'a more effective technique approximating to that of the film'.**

In America, his experiments continued, and photography became an important aspect of his educational programme there.

39
Double portrait of an old woman
undated, before 1936
positive and negative camera photograph
(new print)
20×25

40
Moholy photographing his own shadow
c1926
camera photograph (new print)
24×18

41
View straight down from the Berlin
Radio Tower
c1928
camera photograph (new print)
24×18

42
Nude
1931
negative camera photograph
(vintage print)
26×38

43
Portrait of Penelope Chetwode,
Lady Betjeman
1933
camera photograph (vintage print)
24.1×17.8
Sir John Betjeman

44
Bexhill Pavilion with people
undated 1935—1936
camera photograph (vintage print)
21.5×17

45
Dusk at the playing fields of Eton
undated 1935—1936
camera photograph (photo-repro)
27×22

46
Eton portrait
Recently discovered, vintage
camera-photographs, taken by
Moholy-Nagy for the book by
Bernard Fergusson, but not used
undated 1935—1936
all 21×16

44

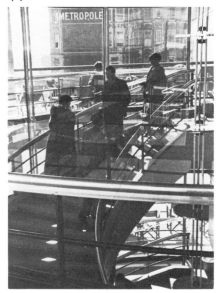

44
Moholy took this photograph for both the
Architectural Review's article, *Leisure at
the seaside* (July 1936), which he designed,
and the Pavilion's architect, Serge Cher-
mayeff, who had designed this English
monument (opened December 12th 1935)
to the Modern Movement with his German
refugee partner, Erich Mendelsohn. The
spiral staircase provided Moholy with a
remarkable example of one of his favoured
space-time symbols.

47
An Oxford University chest
twenty-seven recently discovered camera
photographs, taken by Moholy-Nagy for the
book by John Betjeman, only two of which
were used (f and g)
undated 1936
all 9×13 (new prints)

48
Old man feeding pigeons, London
undated 1935—1937
camera photograph (new print)
24×18

49
Two portraits of Sibyl Moholy-Nagy in
England
undated 1935—1937
camera photographs (new prints)
each 24×18

50
Parking Lot, Chicago
1938
camera photograph (photo-repro)
28×34.4
Victoria and Albert Museum

Moholy-Nagy

Photoplastics

In retrospect, Moholy used the term, 'photomontage', for these works, but in the 1920s, he distinguished strictly between them and their immediate predecessors, the Dadaist photomontages with their brutally cut elements which often lost any meaning in their disjointed, highly individualistic connections 5,8. However, he admitted that his photoplastics, as well as his photograms, were an outcome of influence from Dadaism, Schwitters' Merz painting, and Cubist collages 14,72.

Moholy proposed photoplastics as a clear demonstration of the way imitative photography could be made more purposeful and creative by expanding on the Futurists' attempts to express directly the way we experience many events at once— called 'simultaneity'. He employed the then recent example of a provincial visitor's paralysed bewilderment faced with the unfamiliar, multifarious sounds of traffic and commercial life on Berlin's Potsdamer Platz (c.1927) to show how vast technical developments and the growth of cities had extended and sharpened the city-dweller's senses 4,43. There was comparable, simultaneous complexity, he argued, on the visual front:

'one travels in the tramcar, looks out of the window. behind, drives a car. likewise the windows of this car are transparent. through them one sees a shop, which in turn has a transparent window. inside, people, shoppers and traders. another person opens the door. in front of the shop walk passersby. the traffic policeman stops a cyclist. one grasps all of that in a single moment, because the panes are transparent and everything is happening in the line of sight' 5,9.

He wanted to demonstrate this kind of experience, an organised synthesis of such mixed events, including mental associations, in a lucid, condensed dimension which would involve the objective records of camera photography, unified, but in unexpected tensions with, drawn additions, producing what he called composition with new objectives, **'a railway-track of ideas'** 5,9.

Moholy felt that photoplastics would express the wit of the future, and were uniquely capable of effecting, even in subliminal ways, **'amusing, stirring, overwhelming, satirical, visionary, revolutionary, etc, results'.** Their titles were calculated **'to meet the understanding half-way',** and while some of them already might bear more than one title, the significant **'convincing truth'** might frequently be reached by the spectator's own further suggestions 5. Their very topicality can now perhaps make them appear rather obscure since the world and values that they express are so remote. He saw their application in, for instance, theatre or film scripts, where the whole programme could be summarised on a single sheet, and in cinema posters, which would present a suitable synthesis of the film rather than convey whole scenes in poetic colours as was then the custom.

Today, such 'photoplastic' cinema posters, and even television advertising are stock-in-trade. The intentions behind the photoplastics formed the basis of his ideas about what he called **typophoto,** the full exploitation of interrelated text and illustrations, or illustrations alone, to communicate an objective, unambiguous message for **'the new visual literature'** 4,40.

51
The structure of the world
1925
photoplastic (photo-repro)
35.2×27.7
Victoria and Albert Museum

52
Murder on the rails
1925
photoplastic (photo-repro)
24×18

53
Leda and the swan
1925
photoplastic (photo-repro)
18×13
Victoria and Albert Museum

54
Behind God's back
1926
photoplastic (photo-repro)
37×28.8
Victoria and Albert Museum

55
Jealousy
1927
photoplastic (photo-repro)
30×24.6
Victoria and Albert Museum

51

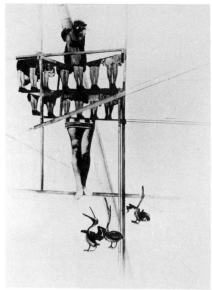

54

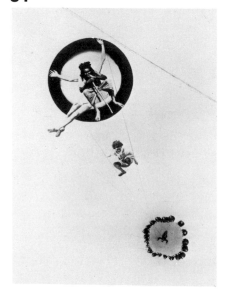

51

'The photomontage can be dramatic, lyrical; it can be naturalistic, abstract, etc. Here is a satirical montage, making fun of the fright of the monkey and the quack-clacking super-geese (pelicans) who discovered the simplicity of the world constructed as a leg show.' From L Moholy-Nagy's caption to an illustration of this work in his book, **Vision in motion,** 1947, p213.

53

'Linear elements, structural pattern, close-up, and isolated figures are here the elements for a space articulation. Pasted on a white surface these elements seem to be embedded in infinite space, with clear articulation of nearness and distance. The best description of their effect would be perhaps to say that each element is pasted on vertical glass panes, which are set up in an endless series each behind the other.' From L Moholy-Nagy's caption to an illustration of this work in **American Annual of Photography,** Boston, 1942, quoted by Kostelanatz, **Moholy-Nagy,** 1971, p65.

Film

Although Moholy's interest in productive, new experience, light, and kinetics pointed to film as the 'optical focus' of his age (1927), and, above all, capable of fulfilling the 'requirements of a space-time visual art' (1946) *15,* he was unable to begin to film until 1926, for want of funds. His film manuscript, *Dynamic of the metropolis 1921—1922,* prepared with the help of Karl Koch, probably could have become the pioneer example of what he called the *FILMIC,* that is film which proceeded **'from the potentialities of the camera and the dynamics of motion',** if he had found backers *4,122.* Most of his films were documentaries structured according to his idea of the 'filmic', or, what came to be known as 'symphonic form' after Ruttmann's series of 'Symphony' films, beginning with the influential *Berlin, symphony of a city 1927,* based on the evolving momentum of the work-day. The present exhibition brings to light Moholy's only surviving sound-film, *Lobsters 1935—1936,* made during his English period. His formal vocabulary of the early paintings dictated his film imagery, although the impact of his contact with the socialist ideals of John Grierson and his governmental Documentary film Movement is plainly visible in the way Lobsters echoes narrative and formal aspects of Grierson's own, pioneering documentary about the British herring fleet, *Drifters 1929.*

Moholy's belief that all photographic processes reached their highest level in the film (what he called 'relationships between the motions of the light projections') *4,33,* and his identification of the next task after the photogram in 1927 as 'light films which could be shot continuously', *4,44,* lead to the disappointing fact that only one of his three abstract films has survived, *Light play, black and white and grey 1930,* based on the Light prop. Later, he looked back upon this film (although now incorporated into an extended script) as a fulfilment of his desire for the black-white-grey gradations of the photogram…in continuous motion *19.* *ABC in sound* (Tönendes ABC, *1932),* an experimental film based on synaesthesia (in this case, the sound of visual appearance), presented letter sequences, finger prints, geometric signs, and drawn profiles in duplicated pairs, one forming the sound track, the other the projected picture. Consistent with the reasoning behind his distorted photographic views, he was side-stepping, for instance, conventional spoken responses to the appearance of familiar letters to reach an objective, universal translation yielded by technology. Another lost film (c.1935—1936) played on illusion and the physical limits of film-space, and-time, by presenting two discs, side by side, which moved backwards and forwards in opposition to one another for some minutes before ending with the abbreviation, 'etc.' His paintings spring to mind as precedents for this alternating emphasis between foreground and illusionistic depth, and the implication that the action continued beyond the physical boundaries of the medium (for example, *Composition A 18 1927*). Richter's *Rhythmus 21 1921,* although different in programme, is an early hint at the power to be expressed by the simple device of moments of alternately, receding and emerging rectangles and squares, and, incidentally, with *Rhythmus 23 1923,* shows animated strips compounding configurations of various kinds in their rhythmic convulsion of the picture space.

In his Bauhaus Book, *Painting, photography, Film,* he discussed the primary role of productive, new creation in human development, and demanded the expansion of media that, had been used only to reproduce ■

His belief that film should be a primary creative tool makes his special effects for the Korda film, *Things to come 1936* ● interesting for a number of reasons. He contributed a sequence of effects from which the editor chose desired sections for the interlude conveying the reconstruction of Everytown, which, as the author, H G Wells stipulated, would bridge 'as rapidly and vigorously as possible, the transition from the year 1970 to the year 2054'. As Wells wrote, this 'age of enormous mechanical and industrial energy has to be suggested by a few moments of picture and music'. Eventually, only about ninety seconds of the five-and-a-half-minute sequence of Wells' 'powerful rotating and swinging forms' and 'enigmatic and eccentric mechanical movements' were supplied by Moholy, and his name is absent from the credits. However, notable from his contribu-
●

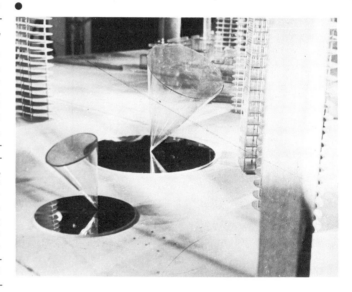

tion are **a** a shot of his mercury-filled glass and metal kinetic sculpture, *Gyros 1930—1936;* **b** a helmeted technician viewed through corrugated glass; **c** a revolving spiral; **d** glass tubes; **e** oblique, cellular patterns changing, by irregular, fragmented action, into a shooting spray of light particles; and **f** the light-distorting oily and smoking effects. What appears to be a table-spoon, in closeup, behind a glass retort and lengths of perspex, is another inventive means of light play from his sequence.

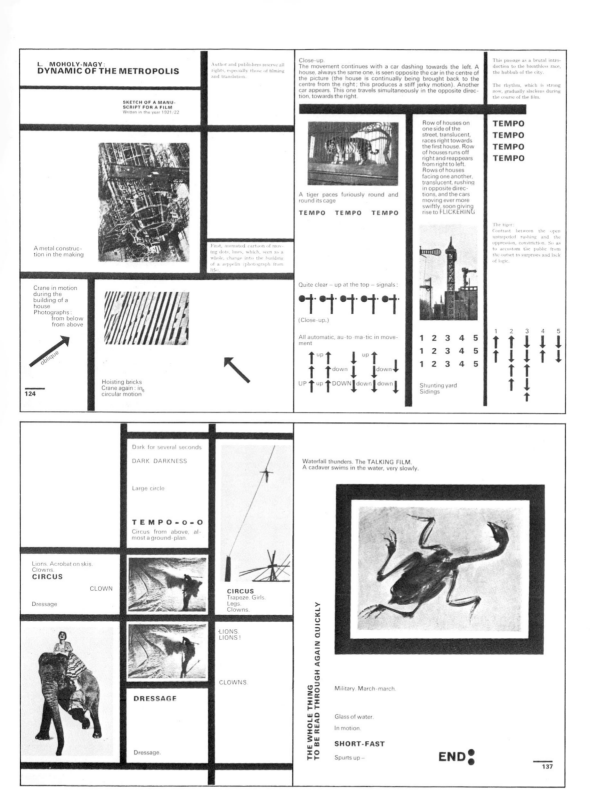

Pages from his book **Painting, Photography, Film,** showing Moholy's proposal for a graphic story-board, bringing together a variety of elements into a vital association of events, in space and time. **Dynamic of the Metropolis** sketch for a film 1921-22.

Moholy-Nagy

Commercial and industrial design

When Moholy's ideas found their way into this category, they reached a vastly wider audience than his private paintings, sculptures, or photographs could ever hope for. Sibyl Moholy-Nagy has quoted him as telling an audience at the Stedelijk Museum, Amsterdam, during his exhibition there in 1934 that:

'We (the revolutionary artists of 1920) believed that all-or-nothing solutions would create a visual order expressive of a new world. You can learn from us that it is the infinitely slow adaptation of the masses to new socio-visual standards that guarantees educational progress.... There's no task too small and no project too big to make it a manifesto of incorruptible design: a label, a photograph or a million-guilder housing project. And there's no one too pompous or too humble to be made an ally—a big industrialist or the woman who washes your shirts' *32, 109—110*

Here is invoked his feeling that as a young painter he was throwing a message, sealed in a bottle, into the sea, that might take decades to be found and read. In the mid-1920s he had believed that most of his contemporaries had 'the outlook of the first steam locomotives', and, in 1943, that 'most adults never know what is going on in their own times.' *4,34; 43,16-17.* But as early as 1925, he had expressed his faith in the sound 'instincts and preferences' of the 'much disdained masses', an outlook that he confirmed twelve years later in London, when his paintings encountered many critics' incomprehension.

In England, one writer reported him as considering that he had two distinct sides: the painter and the commercial designer, and that as a designer he would decide first of all what he thought was best for the product, rather than forcing any aesthetic belief, whereas in his painting, he would not compromise.

In Germany, Moholy's graphic design formed a pioneering part of the new asymmetric typography which depended for its impact on a fresh attitude to the design space, and to the priority of the message in relegating the various elements to an order of visual force based on their relative importance. Ironically for his policy of aiming at universal expression through the use of objective, neutral forms, in England, unfamiliar with such imagery, this alone was enough to make him appear distinctly individual.

Moholy's painterly vocabulary of interests found commercial expression from his typography for the Bauhaus Books (recalling the repeated strips of the oil-painting K VII, *1922*), and heat-proof glass advertisements for Schott & Gen Jenaerglas (transparency), to window display layouts for Simpson's (Piccadilly) Ltd (repeated elements in regimented, Constructivist arrangement), and the Parker '51' fountain pen (employing the new materials for simplicity and richness).

His ideas about clear, objective communication by means of an organic totality of photographs, with, or without, interrelated text, produced what he termed **'typophoto'**, and this, together with his search after 1935 for **'a unity of all graphical techniques ... in the preassembly of the object to be "printed"'** *44,* began to reach expression in the article, **Leisure at the seaside** Architectural Review July 1936, and his last book, **Vision in motion** 1947, through the special interest of the publisher, Paul Theobald. He regarded his pamphlets and posters as a preparation for his pool of technical and

formal means to meet the demands of new, more immediate advertising communication. In keeping with his early belief in the possibility of dividing conception from execution, he employed Gyorgy Kepes (1930-1943) to carry his commercial work to completion.

56
Malerei, Fotografie, Film, by
L Moholy-Nagy
1927
Bauhaus Book 8, Albert Langen Verlag,
Munich. Second Edition
cover and typography by L Moholy-Nagy
23.5×18.5
Terence A Senter

57
Von Material zu Architektur, by
L Moholy-Nagy
1929
bookjacket for Bauhaus Book 14,
Albert Langen Verlag, Munich
22×18

58

58
14 Bauhaus Bücher
1929
prospectus for the fourteen Bauhaus
Books, Albert Langen Verlag, Munich
15×21
Victoria and Albert Museum Library

59
Die Neue Linie
September 1929
cover design for the Berlin periodical
36.5×26.4
Victoria and Albert Museum Library

60
Die Neue Linie
February 1930
cover design for the Berlin periodical
36.5×26.4

61
60 Fotos, edited Franz Roh
1930
Victoria and Albert Museum Library

62
The New Vision
1930
20.5×26.3
Victoria and Albert Museum Library

63
An outline of the universe, by JG Crowther,
London, Routledge
1931
a original bookjacket design, 1930
16×25

b bookjacket
14×22.2

Victoria and Albert Museum Library

64
Das Leben ist anders
undated 1929—1935
leaflet for the Berlin periodical
Der Konfektionär
16.2×24.2
Victoria and Albert Museum Library
64 see page 61

Moholy-Nagy

65
Work for Imperial Airways, London
a cover design *Imperial Airways gazette*
April 1936,
20.4×26
Terence A Senter

b poster-map, Imperial Airways map of
Empire and European Air Routes
April 1936
99.4×63.5
British Airways Archive

c booklets *Empire Airmail programme*
1937
two versions
19.4×26.7
British Airways Archive

66
Schott and Gen. Jenaerglas
undated (c1935) seven leaflets
14.5×21 to 13×22.3
Victoria and Albert Museum Library
66 see page 61

67
The new architecture and the Bauhaus, by
Walter Gropius, London, Faber
1935
a bookjacket and cover by Moholy-Nagy
14.6×20.5
Michael Collins

b four alternative designs for the
bookjacket
photographs, all 24×18

68
The streetmarkets of London,
by Mary Benedetta, London, John Miles
1936
a bookjacket
22.2×36.2 (open)
Victoria and Albert Museum Library

b book: typography and photographs
22.2×14.5
Terence A Senter

68

68

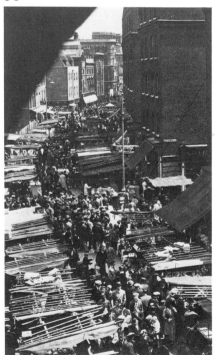

69
Eton portrait, by Bernard Fergusson,
London, John Miles
November, 1937
a bookjacket
25.5×59 (open)
Laurence Hayward

b book: typography and photographs
25.5×19.8
Terence A Senter

70
An Oxford University chest, by
John Betjeman, London, John Miles
December 1938
a bookjacket
25.5×22 (front and spine only)
Victoria and Albert Museum Library

b Book: typography and vast majority
of photographs
25.5×19.6
Terence A Senter

71
The face of the Home Counties
by Harold Clunn, London, Simpkin Marshall
October 1936
bookjacket
25.5×36.7 (open)
Terence A Senter

72
Lobsters
1936
film brochure by Moholy-Nagy to
accompany his film of the same title for
Bury Productions
15×22

73
L Moholy-Nagy exhibition
London Gallery, Cork Street, London
December 31st 1936—January 27th 1937
a announcement card
20.3×13
Victoria and Albert Museum Library

b catalogue
introduction by Siegfied Giedion
Victoria and Albert Museum Library

c folder
designed by Ashley Havinden
21×12.5
Harry Blacker

75

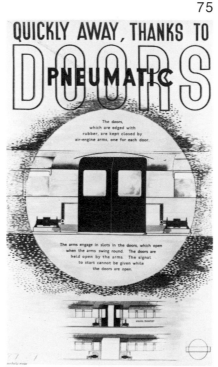

73

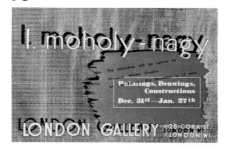

74
Menu for Gropius's farewell dinner before
departure for America
1937
Folder design, London
two specimens
a private collection
b Michael Collins

75
Posters for London Transport
a Your fare from this station, c 1935

b Your fare from this station, c 1935
 (alternative version)

c Quickly away, thanks to Pneumatic
 doors, 1937

d Soon in the train, by escalator, 1937

colour lithographs
101.6×63.5
London Transport Executive

75
Here are examples of Moholy's work for the
second of Britain's major, four advertisers,
London Transport, whose distinguished
publicity policy had been inaugurated by
Frank Pick in 1915. Moholy joined the ranks
of many, outstanding artists employed by
London Passenger Transport Board in its
aim to project an ideal, intimate image to
the public. The Art critic, Roger Fry, had
observed in 1925 that people at large had
become accustomed to genuine works of
art on the walls of the tubes, trains, and lifts.
Moholy's familiar, painterly devices are evi-
dent here: the circle and strip (which, in (b),
become the train and focusing element), the
speckled colour, the rough-brushed display
areas, formal repetition, and varied type-
faces such as he had explored earlier at
International Textiles, in Amsterdam.

Moholy-Nagy

76
Work for the Isokon company
a Isokon letterhead
notepaper sample
1936
17.8x22.8

b The new Isokon chair
publicity folder
1937
68.6x15.2 (2 copies)

c Invention that makes life more
comfortable
translucent folder
1937
45.8x12.8

d Isokon Bookshelves
showcard
1937
12.8x15.2

The Pritchard Archive
University of Newcastle upon Tyne

77
The New Bauhaus
a Prospectus
1937

b Folder: night class and Spring semester
1938
21.5x14

Harry Blacker

78
Children's children by S D Peech,
New York, Bittner and Co
1945
bookjacket
20x26

79
Parker '51' fountain pen
1941
Parker Pen Company Ltd, Sussex
79 see page 54

80
Berlin building unions exhibition
1929 display by L Moholy-Nagy and
Herbert Bayer

81
Film and Foto
International exhibition of the German
Werkbund,
Stüttgart
May 18th—July 7th 1929

82
Madame Butterfly, Kroll Opera, Berlin
1931
stage-set by L Moholy-Nagy
photograph by Lucia Moholy

83
Things to come
1935—1936
sixteen photographs

84
Utrecht Jaarbeurs
March 1935
six photographs

85
Brussels International Exhibition,
artificial silk stand
April—November 1935
four photographs

86
The Empire's Airway,
three exhibitions of that title for
Imperial Airways
a Science Museum, South Kensington,
London
December 6th 1935—February 2nd 1936
three illustrations

b Charing Cross Underground Station,
London
June 18th—July 7th 1936
two photographs

c Exhibition train
July 12—December 3rd, 1937
one photograph

d Booklet to accompany the exhibition of
the same title staged by Imperial Airways at
the Science Museum, South Kensington,
London
December 6th 1935—February 2nd 1936
21x14

Harry Blacker

81
This special exhibition in room 1 was compiled and arranged by Moholy. Although three photoplastics by Moholy were shown **(Girls' boarding school** 1925; **Once a chicken always a chicken** 1925, and **Pneumatic** 1926), the room concentrated on working photography in the service of the community and industry including the police, zoo, press, science, and photographic and film laboratories. 'Where is photography going?' read the caption, and the catalogue reported that 'the attempt was made to organise systematically the various work spheres of photography from the stand points of documentary capture of the world, the fixture of movement, and conscious creation with light, and to present them in groups.' Moholy was indebted partly to the singular collection of historical photographs owned by Professor Erich Stenger of the Berlin School of Technology.

Moholy also arranged the design of room 5, devoted to himself, which displayed ninety-seven photographs, photograms, and photoplastics, described in the catalogue as 'from a book shortly to appear from Albert Langen Verlag, Munich'—possibly his projected Bauhaus Book, **Structure of design,** which had been advertised as in preparation in 1927.

82

'One of the most important means of expression for the stage designer is light. The traditional theatre designer worked with dispersed light without any shadow. But light without shadow is lifeless.'

'In order to achieve the richest play of shadows, in all my theatre work I have tried to dissolve the straight and plain surfaces into curved planes, and have used skeleton walls which cast open not solid shadows. This 'Butterfly' was designed for a stage which allowed a quick change of scenery by moving in at the end of the act to one of the side stages (the 'wings') and rolling in a new set from the other side. This facility made possible the building of a double-set, comprising the middle stage and one wing. This allowed a change of scene before the eyes of the public. During the 'garden aria', for instance, while the middle stage was rolled away into the left wing the singers moved right into the garden. This created the illusion of a long walk since the set previously in the right wing was brought to the centre.

As a backdrop, a gigantic photomontage (a composite picture of Japanese landscape, with a large cutout of the bay) was used. Behind it, on the cyclorama coloured lighting effects, from dawn to sunset, were projected'. From L Moholy-Nagy's caption to an illustration of this work in his book, *Vision in motion,* 1947, p265.

In the theatre, Moholy encompassed the futurists' mechanical stage and El Lissitzky's Constructivist stage, in his attempt to overcome the problem of the actor's limited range.

82

Moholy-Nagy

87

a See it at Simpson—Television, 3pm—4pm
1936
showcard for Simpson (Piccadilly) Ltd,
London
10.5x12.5

b Simpson—clever gifts for Christmas
Christmas 1936
showcard for Simpson (Piccadilly) Ltd,
London
25.5x20

Harry Blacker

88
British Industries Fair
1937
one photograph

89
MARS exhibition
New Burlington Galleries, London
January 11th—28th 1938
one photograph
Terence A Senter

90
United States Gypsum Company, Chicago
1945
exhibition stand designed by
Moholy-Nagy and Ralph Rapson
one photograph

87

Moholy's main income in this country came from his design-consultancy with Simpson, established for him by Ashley Havinden of the agency in charge of their advertising account. In Berlin, Moholy had already had some influence on shop-window display, and now he became successful for his show-windows and interior displays at Simpson's new store for men in Piccadilly. His consultancy lasted from just before the store opened formally on April 29th, 1936, until he left the country on July 1st, 1937.

Gyorgy Kepes assisted him as Chief Designer and Harry Blacker, as Art Director.

90

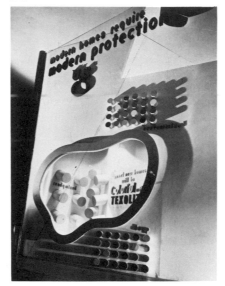

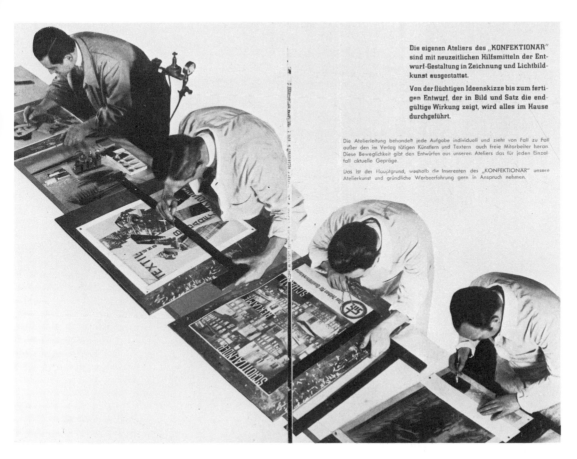

Die eigenen Ateliers des „KONFEKTIONÄR"
sind mit neuzeitlichen Hilfsmitteln der Ent-
wurf-Gestaltung in Zeichnung und Lichtbild-
kunst ausgestattet.

Von der flüchtigen Ideenskizze bis zum ferti-
gen Entwurf, der in Bild und Satz die end-
gültige Wirkung zeigt, wird alles im Hause
durchgeführt.

Die Atelierleitung behandelt jede Aufgabe individuell und zieht von Fall zu Fall
außer den im Verlag tätigen Künstlern und Textern auch freie Mitarbeiter heran.
Diese Beweglichkeit gibt den Entwürfen aus unseren Ateliers das für jeden Einzel-
fall aktuelle Gepräge.

Das ist der Hauptgrund, weshalb die Inserenten des „KONFEKTIONÄR" unsere
Atelierkunst und gründliche Werbeerfahrung gern in Anspruch nehmen.

64
Double page spread from Das Leben ist anders,
1929—1935, a leaflet for the Berlin periodical *Der
Konfectionär*
see page 56

66
Two pamphlets advertising the glassware of Schott
and Gen. Jenaerglas *c1935*
see page 56

Moholy-Nagy

Miscellaneous

91
Photographs of lost works

wood sculpture 1920
metal sculpture 1921/22
construction with an 'h', before 1922
'gyros' watercolour 1935
painting with dots 1935
L *Al* I 1936
L *Al* II 1936
L VI G 1936
Transparent galalith L 1936
Copper 1 1936
Rho 49 1936
Rho 53 1936
hinged celluloid 1936
wire mesh painting 1936
space modulator on galalith 1937
Lo 7 version 1 1937
Lo 7 version 2 1937
untitled on plastic, undated
celluloid painting c1936-1937
trolit picture 1927

92
Photographs of exhibitions

Der Sturm 1924
Bauhaus 1923
Abstraction-création 1934
Brnö 1935
London gallery 1936

93
Photographs of Moholy-Nagy

Lucia Moholy
Moholy-Nagy at easel c1923
Moholy-Nagy in boiler suit 1926
The Dessau Atelier (vintage print)
two views of Moholy-Nagy's house 1925

Gea Augsburg
Moholy-Nagy at la Sarraz 1932

Serge Chermayeff
Moholy-Nagy with camera 1936

Hazen Sise
portrait of Moholy-Nagy c1935-1937

Romeo Rolette
Moholy-Nagy lecturing c1942

Lenders list

Sir John Betjeman	43
Harry Blacker	11b 73c 77 77b 86d 87
British Airways Archive	65b 65c
National Museum of Wales, Cardiff	13
Michael Collins	67a 74b
Galerie Gmurzynska, Cologne	5
Theatermuscum, Cologne	25 26 27
Graphische Sammlung Kunstmuseum, Dusseldorf	18
Scottish National Gallery of Modern Art Edinburgh	10
Stedelijk van Abbemuseum, Eindhoven	11a
Lawrence Hayward	69a
Fischer Fine Art, London	20
Trustees of the Tate Gallery	4
Victoria and Albert Museum	35 37 50 51 53 54 55 58 59 61 62 63b 64 66 68a 70a 73a 73b
London Transport Executive	75
Whitworth Art Gallery University of Manchester	28
Hattula Moholy-Nagy	8 9 14 15 16 17 21 39 40 41 44 45 46 47 48 49 52 57 60 63a 67b 72 78 80 82 83 84 85 86 88 90 91 92 93
Galerie Klihm, Munich	2 6 12 33 34 36
Pritchard Archive The University, Newcastle-upon-Tyne	76
University of East Anglia, Norwich	22
The Parker Pen Company Ltd	79
Private Collections	1 3 7 19 23 29 30 32 42 74a
Terence A Senter	31 56 65a 68b 69b 70b 71 89
Mrs Helen Serger, New York	24
Sir John Summerson	38